DINAS POWYS
ST ANDREWS MAJOR
& MICHAELSTON-LE-PIT

From Old Photographs

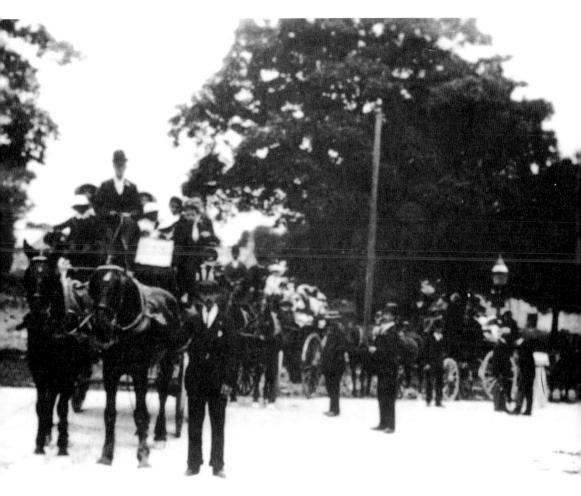

A children's treat ready to leave Parish Road and the Mount Corner in Edwardian days. This was probably one of the chapel treats which the National School master complained 'spoiled the week's attendance'.

DINAS POWYS
ST ANDREWS MAJOR
& MICHAELSTON-LE-PIT

From Old Photographs

CHRYSTAL TILNEY

AMBERLEY

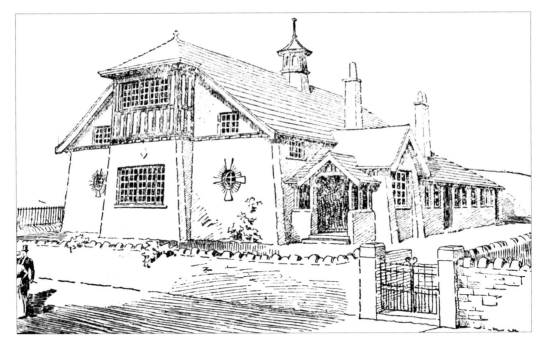

The Parish Hall, Dinas Powys, sketched at its opening in 1907. The village celebrated the centenary in December 2007.

This edition first published 2010

Amberley Publishing Plc
Cirencester Road, Chalford,
Stroud, Gloucestershire, GL6 8PE

www.amberley-books.com

British Library Cataloguing in Publication Data.
A catalogue record for this book is available from the British
Library.

ISBN 978 1 4456 0164 9

Typesetting and Origination by Amberley Publishing.
Printed in Great Britain.

Contents

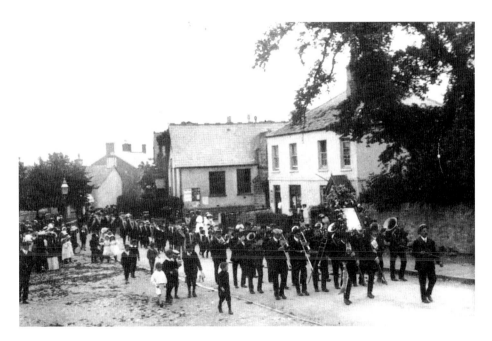

Dinas Powys Silver Band. This was a popular feature of village life in the days before the First World War but it was disbanded in 1914 and its instruments lent to the 3rd Welch, never to return. Here the band is leading a procession of members of a friendly society, probably the Oddfellows, who met in the Parish Hall. They are marching up Village (or Parish) Road, by the Iron Church.

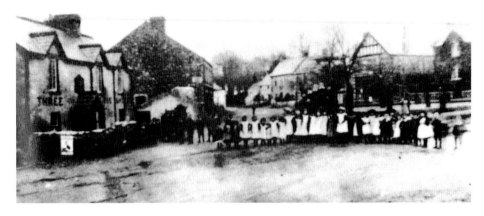

By the Twyn, Dinas Powys, at the beginning of this century. Schoolboys and the girls in their white pinafores are grouped in front of the horse-trough at the corner of the village green – the Twyn. On the left is The Three Horse Shoes and the shops beyond, little changed to this day. On the right is the Schoolhouse, demolished in 1971, the post office (now a private house), and behind the winter trees, the Old Court House and The Star Hotel.

Introduction

At the last census (2001) Dinas Powys was a community of 7959 inhabitants. This included St Andrews, but Michaelston-le-Pit with its 120 households was counted separately. Dinas Powys has its own Community Council but Michaelston is joined to Leckwith, all under the Vale of Glamorgan Council, recalling the Victorian description of the parish church as 'St Andrews-in-the-Vale'. For some years the ecclesiastical parishes of St Andrews Major and Michaelston-le-Pit have been grouped under the same incumbent.

During the Middle Ages, Dinas Powys Castle was the administrative centre of the hundred of Dinas Powys, which comprised 26 parishes. Comparative figures show that as late as 1801 it outranked neighbours like Penarth. Even so, the population of the parish of St Andrews Major was only 474 in 1833. The building of the Barry Railway and the Docks in the 1880s altered the balance of the population and changed a way of life that had remained relatively self-sufficient for centuries. Though its population expanded to 1,149 in 1891, and over 2,000 at the turn of the century, Dinas Powys was outstripped by its neighbours and became a commuter village, a favourite country retreat for those who made their money in the great shipping centres of Cardiff, Penarth and Barry. Their mansions spread out along St Andrews Road and around the outskirts of the village, in striking contrast to the 'railway suburb' that grew up in Eastbrook along the new road to Cardiff. But the green area of the golf 'links' and the woods (Cwrt-yr-Ala, only recently saved for public access by grant and voluntary subscription) have prevented building to the north of Dinas Powys, and at its heart the Common and the Twyn remain inviolate. St Andrews and Michaelston retain their green fields.

Until at least 1920 it was a patriarchal society dominated by the Lord of the Manor, Rector and Schoolmaster. Docksmen, farmers and shopkeepers took a lively interest in the affairs of the community. Until the Second World War, a child growing up in Dinas Powys could claim to know, at least by sight, nearly everyone in the village and this was certainly true of the smaller communities of St Andrews and Michaelston. Those days have passed and Dinas Powys is already being called a small town. Though some buildings and personalities do not appear to have been

recorded on camera, this collection of archive photographs is an attempt to record these old communities and to recall to readers times that are past – and perhaps to send them back to their own photograph albums for snaps which, once purely family history, increase in general interest with every year.

Though the rate of change accelerated with the building of new estates over the farmland after 1945, it is still possible to place the earliest photographs taken over a century ago. The most attractive of these show the people who lived here before us – the schoolchildren and their elders posed stiffly for the camera, and men and women about their business in still familiar locations. It was hard to make a choice from over 600 pictures available, and preference has been given to those not previously published. But some have been repeated from my earlier books, now out of print, because they are so evocative of the old country style of these villages. Changing fashions and attitudes are reflected in such photographs, and a simpler, harder, but less frenetic way of life that has almost disappeared. Many of us would still agree with the opinion expressed by Iolo Morgannwg in 1789, that this is 'the pleasantest village in the Vale of Glamorgan'.

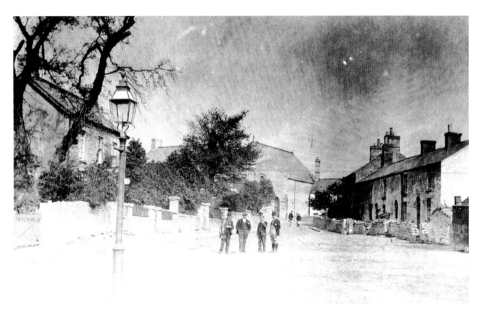

Parish Road, later 'The Square', Dinas Powys. Watching the photographer, Percy Randell, is a typical group of villagers – the postman, two men in cloth caps, one of them smoking a pipe, and, on the right, a farmer or possibly a groom in bowler hat and gaiters. On the left is the gate to the Parish Room, erected by General Lee, Lord of the Manor, for the recreation of villagers, and later closed by him when he heard that it had been used for card-playing for money. Next to that is Brecon House, the telephone exchange from 1890 to 1937. The roof of Ty Eglwys, originally the house for the minister, can be seen across the road from Ebenezer. Ty Capel nestles against the chapel, and on the right is Church Terrace.

One

The Old Villages

According to the National Trust booklet, Villages, *there are a number of reasons for building in any particular place – 'A spring of good clear water, a manor house or castle, a ford, a mountain pass, a crossroad – one or all could justify a village'. A combination of these reasons seems to have operated in this area. All three villages have good fresh water from the spring line where limestone meets clay. Old photographs show wells and pumps at St Andrews, on Mill Road, Dinas Powys and in Michaelston-le-Pit. As for manor-houses, only that at Michaelston was ancient, said to have replaced a Norman tower at Cwrt-yr-Ala, and rebuilt in its turn. 'The Mount', Dinas Powys is a Georgian creation from an old farmhouse. But all three villages were within the protection of fortified places – the original dinas near Michaelston, the Norman castle at Dinas Powys, and Wrinston and Beauville 'castles' (now farms) near St Andrews. The old road from Wenvoe and St Andrews forded the Mill Brook (Cadoxton River) at the foot of Penyturnpike and climbed that steep hill to Cardiff. From the ford, field tracks led through Cwm George, (named after Col. George Rous who opened up this pass between low hills) to Michaelston in its sheltered 'pit'.*

Dinas Powys, perched on its limestone shelf, was the centre from which later settlement grew. Though there was a bakery and a post office in Eastbrook, most of the shops were concentrated round the Twyn, the old village green in Dinas Powys and the vestige of the commonland from which the later village has stretched out in all directions. With the building of the council and then the private estates at the Murch after the Second World War, the commercial emphasis shifted to the shopping centres in Castle Drive and Camm's Corner. As in the past, St Andrews and Michaelston look to Dinas Powys for shops, doctors, schools and public houses. Yet, even today, the three villages preserve distinct identities. The peace of church and cemetery at St Andrews is now broken only by the activity of farms and allotments and the intrusive noise of traffic. From here one passes along the Common to the bustle of Dinas Powys with its shops and estates, and on to the hidden charms of Michaelston-le-Pit in its bowl of wooded hills.

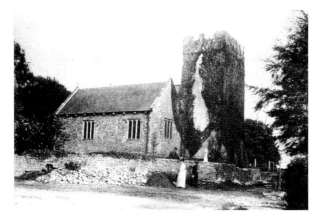

St Andrew's, *c.* 1900. Visitors are viewing the ivy clad tower of St Andrew's the parish church. On the right of the stile is the pump attached to St Andrew's Well. Since 1890 the white cross has marked the grave of Mrs Constance Lee, wife of the Lord of the Manor.

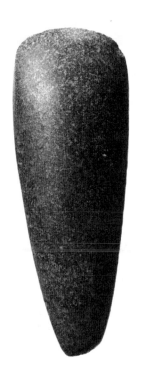

Neolithic axe-head from Dinas Powys Quarry, which was discovered in 1949 by P.W. Brooks. This is probably the oldest artefact found in Dinas Powys and is now in the National Museum. Farmers of the New Stone (Neolithic) Age would have used these tools to clear the dense woodland. The wooden handle and the thongs that bound it to the tooled stone axe-head have, of course, long disappeared.

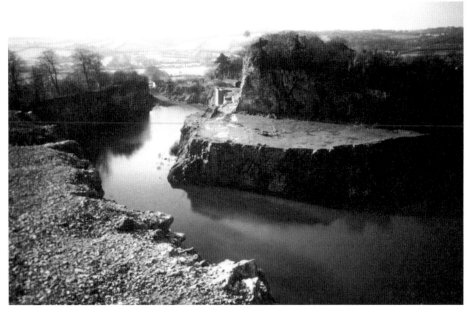

St Andrews Quarry. Limestone has been quarried here for centuries and the quarry has bitten deep into Garnhill Wood. The building stone from here was particularly hard, and was used for the windows of St Peter's Church in 1930. It also produced roadstone and gravel, and many lorry loads went to form the foundation for the supply depot at the Bendricks in 1939-40 (see also p. 72). A village legend links these rocks with the next picture.

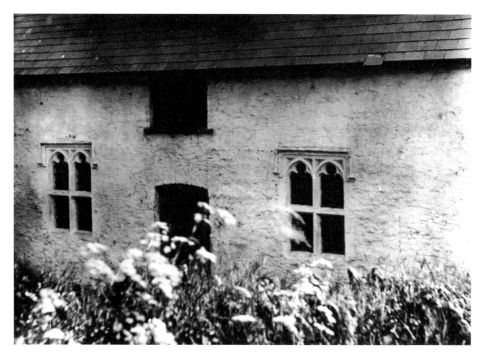

The Old Parsonage, St Andrews, *c.* 1900. This medieval house is close to the church and was occupied by successive incumbents until about 1830 when it became first the coach-house and then the garage of the Georgian rectory. The two-light windows were probably brought here from the church in the early sixteenth century. When it was first described in the *Terrier* of 1771, it was 'chiefly covered with Cornish tyle and partly thatched'. Its most interesting occupant was probably Dr Hugh Lloyd, Rector at the outbreak of the Civil War. He was captured by Roundhead troops on the battlefield at St Fagans, imprisoned and dispossessed of his living. Legend has it that he remained in the area after his release, and would often climb up to a rocky eminence (perhaps now quarried away) that became known as 'Cadair yr Esgob' ('The Bishop's Seat'). At the Restoration, Hugh Lloyd became bishop of Llandaff and is buried in the Cathedral.

Garnhill Farm. The photographer has given prominence to the wagon, a working vehicle, but so much more 'picturesque' than the modern tractor. The first documentary evidence of Garnhill occurred in 1609-10.

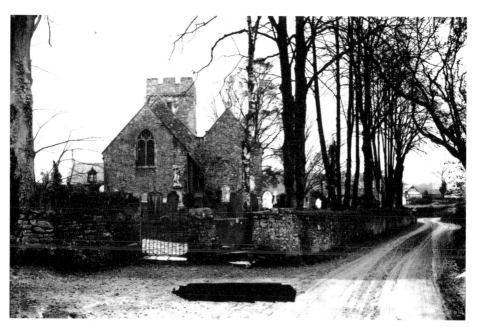

St Andrew's church before 1920. A burial chapel at the end of the north aisle fell into ruin in the early nineteenth century, and the blocked archway and squint can still be seen, with a white gravestone actually built against the wall. An earlier stone moved out of the chapel and now much weathered bore the names of John Gibbon James and his wife, 'He aged 99, she aged 124'! In the distance on the right is Ty Gwyn, once The Five Bells Inn, which was closed in the mid-nineteenth century after the Rector's protests about rowdiness there following funerals.

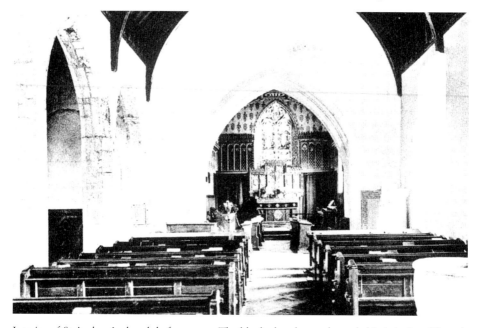

Interior of St Andrew's church before 1920. The blocked archway shows behind the late fifteenth century arcade on the left. The font on the right is Norman, but most of the interior was remodelled during the Victorian period, when the chancel and the sanctuary were richly coloured.

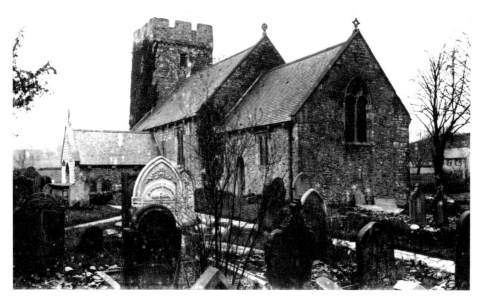

St Andrew's from the south-east, before 1920. This shows the thirteenth century nave and chancel to which the porch and tower were added in the late fifteenth to early sixteenth century.

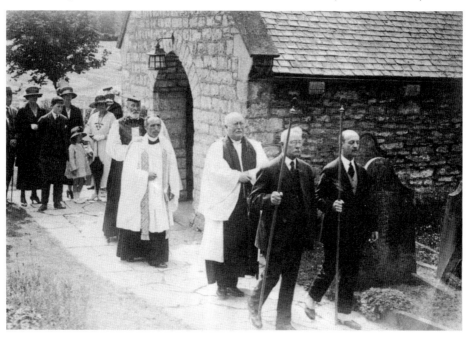

Procession from St Andrew's, 21 June 1922. Following the death of the Lord of the Manor, General Lee, in 1920, it was decided to rebuild the north aisle chapel in his memory. Work proceeded through 1921 (see p. 76) and the chapel, designed by Colonel Wilson, the diocesan architect, was dedicated in 1922 by the Bishop of Llandaff, the Rt Revd Joshua Prichard Hughes. Leaving the church, the Bishop is preceded by the Rector, Revd Edward Davies, Archdeacon David Davies (a former Rector) and the churchwardens, Thomas Cooke and George Whiteside.

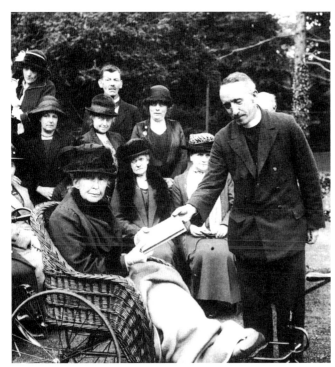

Mothers' Union presentation, 2 June 1924. Mrs Mary Alexander was Enrolling Member of the St Andrews branch of the Mothers' Union from its inauguration in January 1894 until her retirement in 1924. Here, on the Rectory lawn, Revd Edward Davies is presenting her with a vellum, gold-embossed and autographed album as an expression of 'sincere affection, appreciation and gratitude' for her thirty years leadership. The volume is illustrated with pen and ink sketches of local scenes, and contains the signatures of the sixty-four members present.

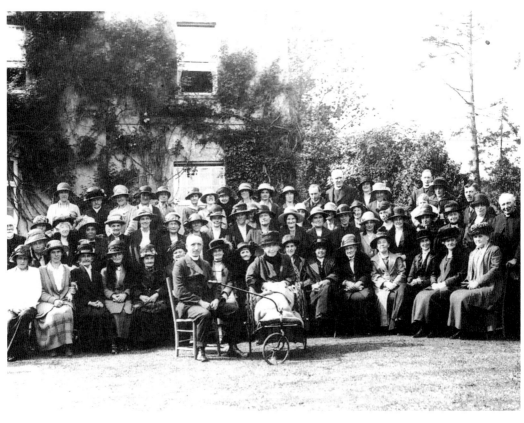

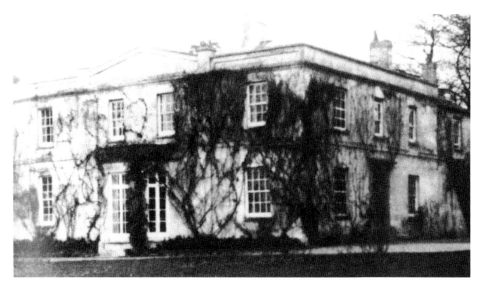

The Georgian Rectory, St Andrews, early twentieth century. This was built about 1830 to replace the medieval parsonage house. There were problems with rainwater, so, in the 1920s, the pediment and parapet were removed and a pitched roof was added. The Rectory lawns were the scenes of many church gatherings, as well as village celebrations like those for Queen Victoria's Golden Jubilee in 1889.

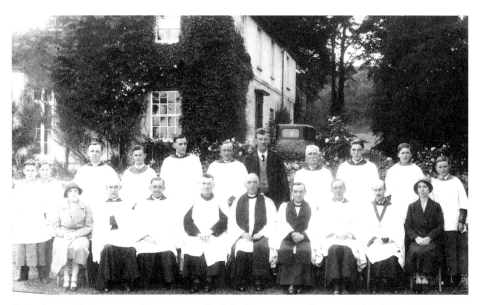

St Andrews Choir, 1930s. The new roof of the Rectory can be seen behind this choir group. The photograph marks the retirement of the organist, Mr Seymour. From left to right, standing: Hedley Lewis, Neville Gadsby, Stan Williams, David Whiteside, John Barnett, Oliver Ridout, Arthur Henn (Verger), Mr Seymour Snr, Jack Ridout, Vivian Scourfield, Albert Osborne. Seated: Miss Dot Williams, H.E. Palmer, George Ridout, Mr Seymour, Revd Edward Davies (Rector), Revd H.H. Williams (Curate), Hubert Ridout, George Whiteside, Miss Janie Voyle.

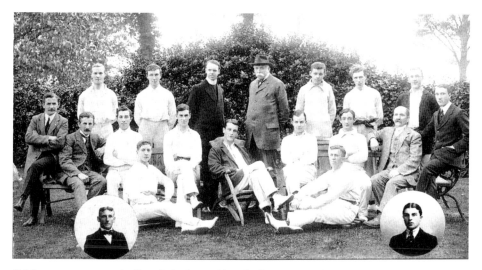

Cricket team, *c.* 1919. At first, St Andrews Choir had its own cricket team which in time merged with the village team. Many church members are in the group pictured here. Its patron was General Lee who was churchwarden as well as Lord of the Manor. On his right is the curate. Mr H.N. Rees took the centre as captain with Bert Griffiths and Jack Morgan on his left. Howell Jones, the headmaster, is seated on the extreme left.

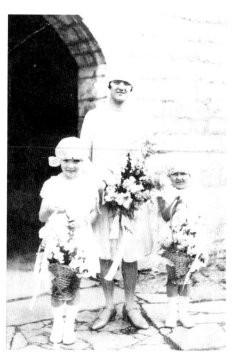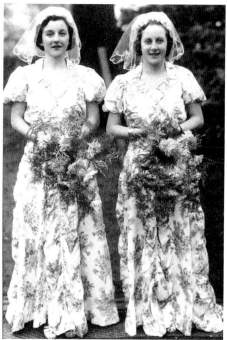

Changing fashions for bridesmaids, 1920s (left) and 1930s (right). Miss Eva Hardman with Claire Jones and Mary Nork at the wedding of Mr and Mrs F.P. Mason, 6 June 1927. Barbara and Josie James are the bridesmaids on the right, in the style of the 1930s.

Canon Hilary Jones was Rector of St Andrews from 1943 to 1964 and was keenly interested in the history of his parish. He was the last incumbent to live in the Georgian Rectory, which he purchased on his retirement. His family still live there. A new rectory was built on The Lettons, close to St Peter's Church, Dinas Powys in 1965.

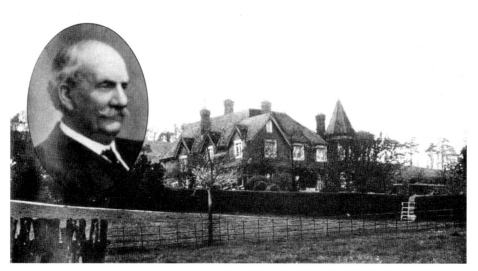

'Bryneithen' – one of the large mansions strung out along the St Andrews Road. It was built in 1891 for David Thomas Alexander (inset). His grandfather had come from Newmarket to Penmark in the eighteenth century to manage the racing stud and estate at Fonmon. After attending school at Cowbridge (where he witnessed the passing of the last stagecoach) 'D.T.' was apprenticed to a draper in Aberdare, but in 1864 he started his own estate agent's business and prospered as the head of the firm of Stephenson and Alexander, with which his descendents are still connected. He became a JP, President of the Auctioneers' Institute of Great Britain, and prominent in South Wales agricultural shows and in land valuation. He has left an interesting picture of agriculture and industry in the county in his *Glamorgan Reminiscences*. Today, St Andrews Church-in-Wales School stands in the field in front of 'Bryneithen' which has become an old people's home.

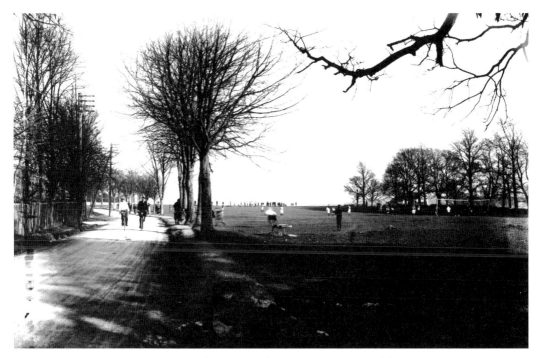

Dinas Powys Common. St Andrews Road runs along the Common, a vestige of the Norman manor now owned and administered by the local council. Common land was a vital part of the manorial economy and 'commoners' had rights of pasturage for their sheep, goats and geese – but not for cattle, as was proven by a celebrated case against Evan Meredith of Malthouse Farm in 1948. The Court Leet made the annual appointment of the commonward or hayward, and Mr Samways was the last to hold this position. The soccer match in progress illustrates the modern use of the Common for recreation.

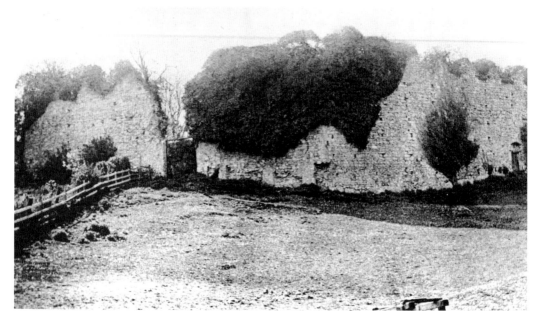

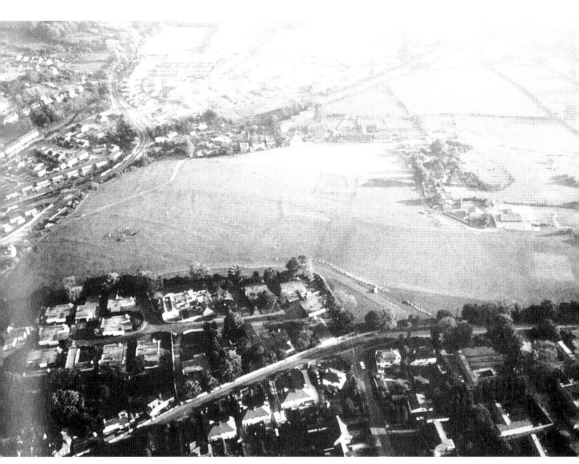

Aerial view of Dinas Powys Common, 1978, revealing the traces of a Romano-British homestead excavated by the Dinas Powys History Society under the direction of Howard Thomas in the summer of 1978. Finds indicated that it had been occupied from the second to the fourth century AD. Middle right is Playhill and the fields of the Southra Farm. Behind 'The Gables' (top centre) the railway line from Barry crosses to the station (centre left). Beyond the railway are the neat lines of the Southra Park estate, occupying the site of Thurston's nursery gardens (see p. 71b) and beyond that the narrow, hedged enclosures that reproduce the divisions of the manorial open fields. New housing has filled the bend of the Barry Road (top left) and the tongue of land where once stood the Malthouse. Even the gardens of 'The Mount' (bottom left) and 'Merevale' (bottom right) are built up. Only the Common remains inviolate.

Opposite: Dinas Powys Castle. The curtain walls contain a ward from which almost all trace of interior buildings has disappeared, but there are ruins of a square keep attached to the north-west wall. The castle was built probably in the late twelfth century (the first documentary mention is in 1222), and was held by the De Sumeri family until the last of the male line died out in 1321. The manor was divided and the castle neglected, so that Leland could describe it as 'al in ruine' in 1536. It had withstood at least one siege by Gilbert de Clare, and the keep may well have suffered at the hands of Owain Glyn Dwr. The main entrance (left) and the postern gate (right) have both suffered from the pillaging of dressed stone by the cottagers when building or extending their houses. The castle was acquired by the local Civic Trust in April 1982, but is now in private ownership.

The Star Inn, *c.* 1900. This, the oldest of the Dinas Powys public houses, contains a Tudor dressed-stone doorway and a spiral stair. The extension with a 'cat-chute' and lean-to (once the blacksmith's and carpenter's shop where school classes were held) were removed when The Star was enlarged to its present appearance. The victorious Cardiff City Football Club was entertained in the large upper room in 1927 on the invitation of Mrs M.A. Lewis with the support of Ralph Morel and Dr Miles. They were regaled with a sausage and mash supper, but no-one thought of taking a photo of the Cup! The fox-hunt met here, and the otter-hunters in their beige jackets. In 1831, the last village 'mayor', William Jenkins, stood on the mounting-block to make a speech before leading the crowd inside for refreshment. On a more sober note, it was from here that men left for war in 1914.

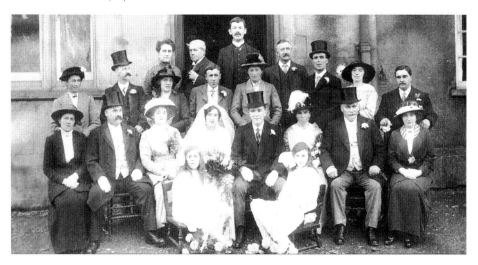

Wedding party at The Star, 5 November 1914. From left to right, back row: Mr and Mrs Bate, Mr Arthur Henn, Mr Johnny Ball, Sid and Sylvia Randell, Billy Lewis. Middle row: Mr and Mrs Stuart Cram, -?-, Mr Crabb, Mrs Deer of The Red Lion, Bonvilston. Front row (seated): Mrs Payne of St Nicholas; Joseph and Ann Bevington; Beatrice Ann Bevington and Walter Lewis (bride and bridegroom); Mrs Mary Ann Lewis; John Martin Prichard of Holme Farm; Mrs Florence Lewis. In the very front, the bridesmaids, Flo and Lily Bevington.

Old Court, 1880. Later known as Old Farm or Old House, this property was first mentioned as 'The Courthouse, also Newhouse, in our Manor of Dinas Powys' in a lease dated 8 October 1639. Mr Dennis Hampton Jeffery, who ran an estate agent's office in Old Court, has established that the property was built c. 1550. The stone-arched doorway leads into a large room possessing an ingle-nook fireplace with a distinctive Tudor-arched wooden beam. A vaulted stone spiral stair leads to the upper storey. Sometimes as courthouse, sometimes as farmhouse, the building has been in continuous occupation since the sixteenth century.

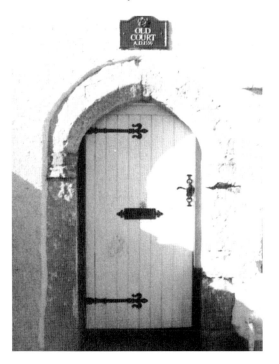

Edward John, estate mason, one of a series of portraits taken by P.G. Randell in the first decade of the twentieth century. Born in 1822, John lived in Ty Eglwys and was employed by the Lee Estate.

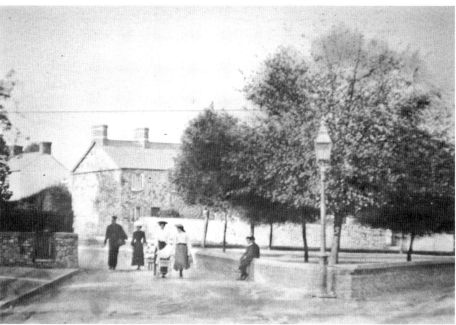

Edward Mason and his mate, Tom Cule, constructed the wall around the Twyn in 1890 and carved their initials on a stone near where the boys are sitting. On the left is the gateway of the Schoolhouse.

Church Terrace was built by Edward John between 1844 and 1850 as a row of dwelling houses, but it got its name of 'Darlings' Arcade' from the couple who sold sweets and had a farthing lucky-dip in the end house.

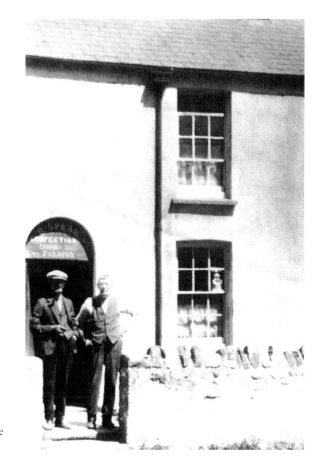

Bert Spear, outside his sweetshop in Church Terrace, 1920s. This sweet shop specialised in 'lucky-bags' long remembered by that generation of village children. When the end house in Church Terrace was condemned as a dwelling, it was converted into a free library by Sir Joseph Davies.

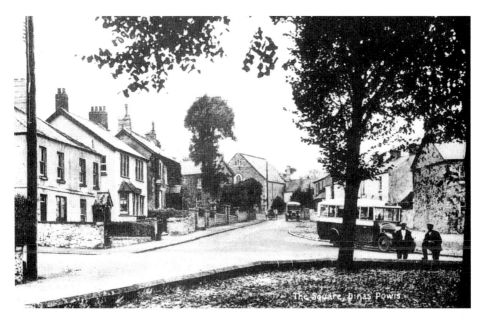

The Square, 1930s (compare with p. 8). Mrs Wright's sweetshop has been built in place of the recreation room, but little else has changed except the forms of transport. The Penarth bus is waiting where the road has been widened, and, at the turn of Highwalls Road, Gwilym John's van is parked outside his grocer's shop. Opposite, the milk-cart has stopped to deliver to Ty Eglwys.

At Brecon House, 1931. Arthur (now Alun) Gwynne Jones was a frequent visitor to Brecon House, where his grandmother, Mrs E.A. Hardman, kept the telephone exchange. At that time he was a pupil at West Monmouthshire School, Pontypool, but he went on to win the Military Cross in the Second World War and to become Defence Correspondent for *The Times*. Created Lord Chalfont of Llantarnam, he held office in Harold Wilson's government from 1964 to 1970 as Minister of State at the Foreign and Commonwealth Office. Here he is at Brecon House with his sister Claire (right) and cousins Mary Nork (left) and the author as a baby.

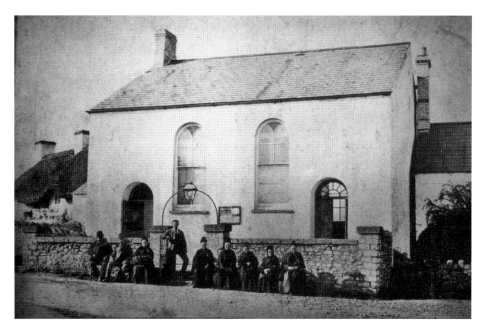

Ebenezer Calvinistic Methodist Church, 1895. This was the second chapel on this site. It was erected in 1839 and photographed just before its demolition. Elderly members of the congregation are grouped outside after the last service. From left to right: J. John the tailor; Thomas John the shoemaker; Mrs Ann Miles; John Howells; Mrs Esther Howells; Mrs Ann Harry, shopkeeper; Mrs Ann Jenkins; Mrs Rimmon; Mrs Cule. Mr Hoosen, the postman, is standing by the gate.

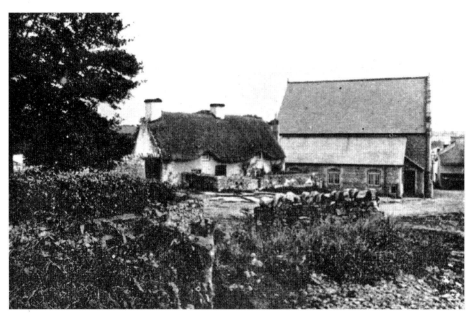

The new Ebenezer, built in 1895 on the same site. The thatched cottage glimpsed in the last photograph is shown clearly here. It was destroyed by fire just before the Second World War. The trodden lime and ash floor of the first, thatched, Ebenezer is preserved beneath the Big Seat, and the back windows are those of the chapel in the previous photograph.

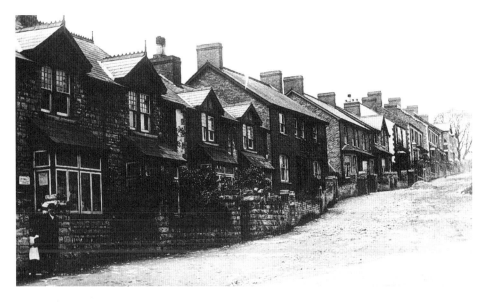

Highwalls Road, *c.* 1908. At this point the road divided into Old Highwalls with its ancient cottages and cobbled surface, and Highwalls Road or Avenue, with turn-of-the-century semi-detached houses up an unmade road. The shop on the left was kept by Mrs Howells, wife of Bill Howells, the lamplighter.

Heol y Cawl or Broth Lane. This steep lane runs downhill from Ebenezer to Mill Hill. The name is derived from the soup-kitchen provided for poorer children in times of hardship. Many of the cottages are eighteenth century, but most have been converted and extended. (Left) Mrs A.C. Williams in the garden of Fitzroy Cottage before its recent conversion. (Right) Dick Williams, the former owner, has returned to inspect the work. Behind him is the original stone stair, and the removal of the plaster has revealed at least two versions of the fireplace.

Gladstone Cottage, 1930s. Joan Davies stands at the gate of a cottage on Mill Hill that has now been demolished and replaced by a modern house at the entrance to Mill Close, once the yard for Hill's Transport.

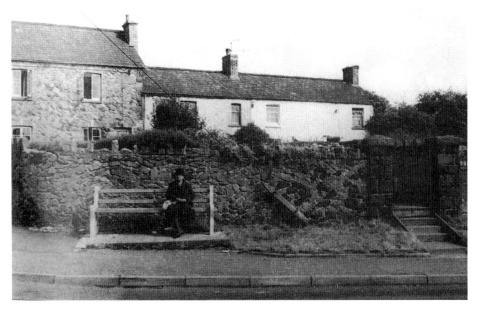

Old cottages on the Square. This eighteenth century terrace nestles against a house built of granite ballast offloaded on the Docks by coal ships in the last century. These cottages are subject to a preservation order, and the whole village centre is now a conservation area.

The Parish Hall, 1907. In May 1907 a public enquiry in the schoolroom (left) heard evidence on the application by the Parish Council for a loan of £1,500 'for the erection of a Parish Hall in Britway Road, Dinas Powys'. The hall was opened on 12 November 1907 by Mrs Jenner of Wenvoe Castle, joint Lord of the Manor with General Lee. It still serves as Council Offices, and has been used for innumerable meetings and entertainments ever since. It was designed by Teather and Wilson and *The Buildings of Glamorgan* (1995) which ignored all the really old village buildings, described it as 'Voyseyish' (C.F.A. Voysey did some fine work nationally including Ty Bronna, Fairwater, Cardiff).

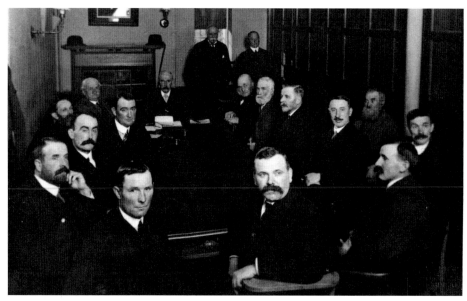

The Court Leet, 4 December 1913. This was the last of the old manorial courts and it met annually to appoint officers like the hayward, to apportion the strips in the open fields before enclosure, and to adjudicate on the payment of tithes, rights of common and the impounding of strays. Clockwise, from the gentleman in the centre, the members present in 1913 were William Williams, Claude Harry, W. Cox, William Harry, H. Harry, Edward Thomas, D.T. Alexander (Foreman of the Jury), J. Whitlock Morris (Steward of the Manor); standing: General Lee (Lord of the Manor) and Claude Thompson (representing Mrs Jenner); William Thomas, David Thomas, Llewellyn Williams, Ralph Morel, J. Samways (Hayward), J. James and Gus Williams. Though a subsequent report in the press suggested that the Court Leet was still meeting in 1921, this photograph from the National Museum is clearly dated 1913, and it is probable that this, like so many other traditions, was ended by the First World War.

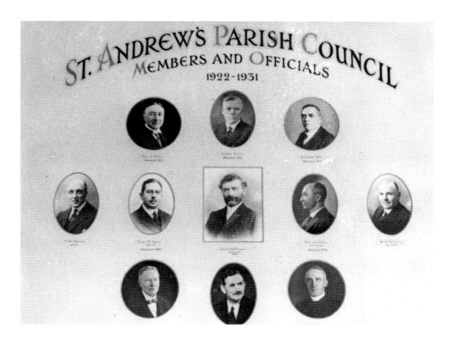

Members and officials of St Andrews Parish Council, 1922-31. The first Parish Council was elected at a meeting in the National School on 13 March 1894. General Lee topped the poll and nine councillors were elected out of the thirteen candidates standing. Later, successive chairmen presented their portraits for this composite picture which hangs in the old library at the rear of the Parish Hall. From left to right, top row: Thomas G. Baker (Chairman, 1927), Ernest Harvey (1926), Gwilym John (1925). Middle row: T.W. Davies (Clerk), Ivor B. Thomas JP (Chairman, 1930), David Williams (1931), D.J. Jenkins (Vice-Chairman, 1923), W. Williams (Assistant Clerk). Bottom row: D.R. Morgan (Chairman, 1928), R. Howell Jones (1929), Revd Edward Davies (1924).

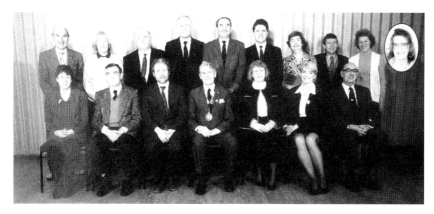

Centenary meeting of Dinas Powys Community Council, 31 December 1994. A special meeting of the Community Council was convened on the centenary of the first Parish Council meeting in 1894. Front row: Councillors Mrs Rosanne Reeves, O.R. Wilson, C.P. Franks, Chairman B.J. McParlin, Mrs Janie Jones, Mrs Val Hartrey, J.S. Roberts. Back row: Councillors G. Williams, Mrs Susan Williams, R.E. Bowen, A.B. Hodgson (Clerk), E.A. Roberts, C.J. Williams, Mrs Marjorie Hughes, M.N. Thomas, Mrs Gale Smith. Mrs Nola Coxon (inset) was the only member of the council unable to be present.

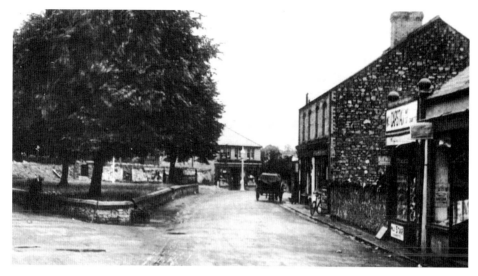

Twyn and Shops, 1930s. Horse and cart are still the customary transport, though a bicycle is propped up outside James the butcher's. The cart has just passed Thomas Rogers, the grocer's (with sawdust floor, chairs for customers, and an aerial 'railway' to convey money to the till). Nearer the camera is the shop of Mr Arthur Ransom, the barber (advertising Capstan cigarettes and tobacco) and a tea-shop that had an interesting history...

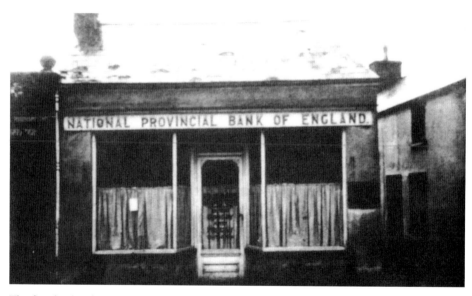

The first bank. This was a sub-branch of the Barry offices of the National Provincial Bank. It closed in 1914 when the new bank was built at the top of Elmgrove Road. Obviously security was not a problem in the original building which later became a tea-shop, a greengrocer's and a fish-and-chip shop. To the right is Eckley Cottage, at one time associated with the Courthouse opposite, as the village lock-up. There was a dame school in the cellar, and it became a butcher's before Mrs Will Spear opened her grocery shop and café in the attached lean-to. It is now a private house, its name recalling one of the old estates.

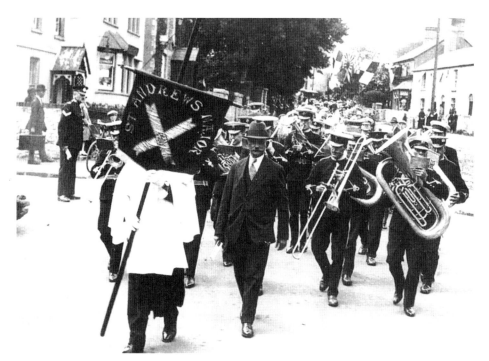

Procession for the foundation of St Peter's Church, 29 June 1939. The banner-bearer Reg Cottrell and Mr Harvey Griffiths lead the procession to the laying of the foundation stone of St Peter's Church, Mill Road. They have started from the Iron Church on the Square which had served as a chapel-of-ease from 1882. But there was need of a permanent building nearer the centre of population than the parish church. The site at The Lettons, Mill Road, seemed ideal. There are flags across the road to Gwilym John's grocery shop. The band and St Andrews Choir below are followed by the clergy, who have been joined by the local Nonconformist ministers in their top hats.

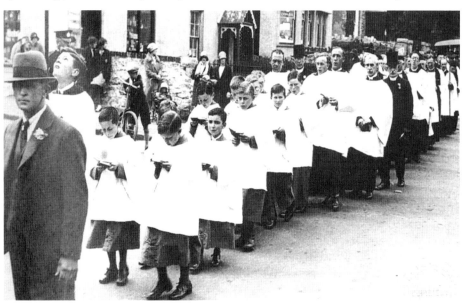

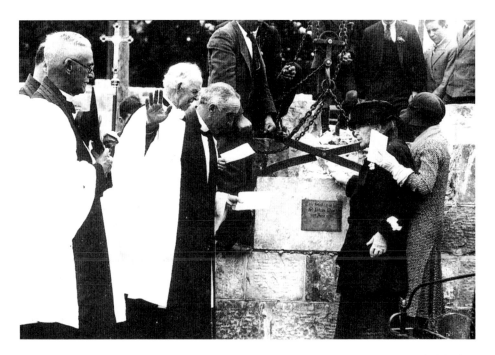

Mrs Mary Alexander lays the foundation stone of St Peter's Church in 1929, watched by her daughter, Miss Grace Alexander; Revd Edward Davies; Canon R. David; Revd Vaughan Rees and Revd Augustus Lee, who gave the site.

St Peter's Church, Dinas Powys, 1930. St Peter's was built of dressed Pennant stone and white lias limestone from the Cyfarthfa Iron and Steel Works, which had recently been demolished. The architect, J. Coates Carter, described it as 'simple in style following the Welsh tradition'. The church stands at the entrance to The Lettons – a name which may derive from the Old English and Middle English words for a herb or vegetable garden. The stonework of one of the old village wells could be seen to the left of the gate. Mr A.W. Spear remembered the water-carrier, a yoke across his shoulders, drawing water from the well and delivering it around the village at a penny a bucket.

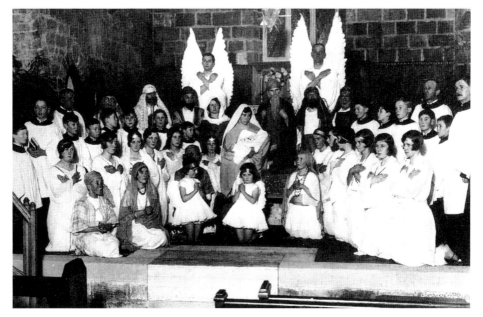

Nativity play at St Peter's, *c.* 1931. This Nativity play, the first in the new church, was a great village event, dominated by the towering wings of the curate (left) and the schoolmaster H.N. Rees (right). On the right, the National School headmaster, Howell Jones, stands with George Ridout among the choir. Stan Williams is unrecognisable as a shepherd with a beard, and Cis Cottrell and Winifred Owen are the baby angels.

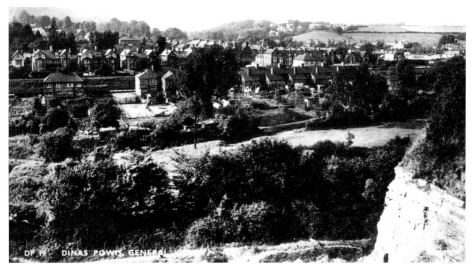

Contrasts in housing, 1930s. With the different housing developments which followed the opening of the railway, Dinas Powys found itself with a variety of architectural styles. The row of railway cottages in Elmgrove Place has been completed with semi-detached houses (compare with p. 75a). Across the railway line we see the attractive three-storey 'villas' of Cardiff Road dating from the first decade of the twentieth century. The older parts of Dinas Powys nestle behind the trees of Elmgrove.

More housing contrasts, 1970s. On the left, Malthouse Farm is already boarded-up and awaiting demolition. Like many farms, it had its own brew-house, but it had also been a butchery, and, for a time after 1892, a cottage hospital for local women. The house, barns and cowshed of local limestone make a striking contrast with the exotic lines of Rockside and Morningside. They stand on land which, until 1885, was part of Murch Farm (its farmhouse now the Methodist manse). Existing labourers' cottages and stables were adapted into a large gothic-style house with gables and turrets. This was divided in two in 1919 and the front portion – 'Morningside' – was remodelled in the style of a Spanish haçienda, perhaps when it was occupied by an Argentinian architect in 1935.

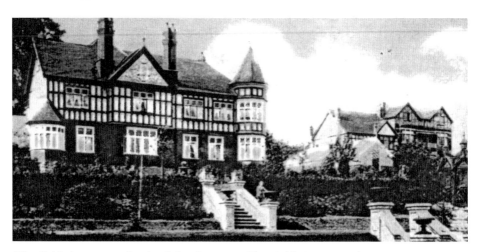

'The Gables', *c.* 1910. South of the Common, 'The Gables' was another attractive mansion with a touch of Victorian Gothic. It was the home of the Cravos family, and afterwards of the family of Judge David Pennant. The modern flats that have taken its place owe nothing to the picturesque.

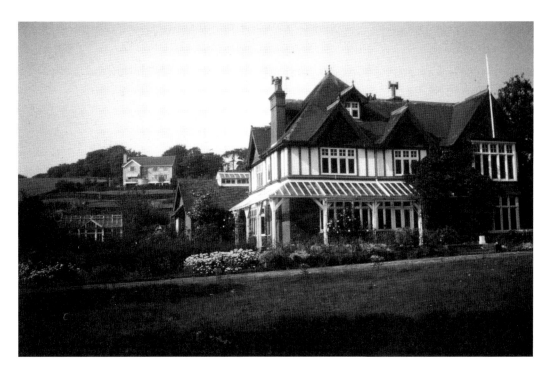

'Merevale'. This was another large mansion which did not see its centenary. Having been a centre of social life in the days of T.P. Thomas, and after him of Mrs E.M. Brain, the house was demolished in August 1973, almost eighty years after the laying of the foundation stone (below).

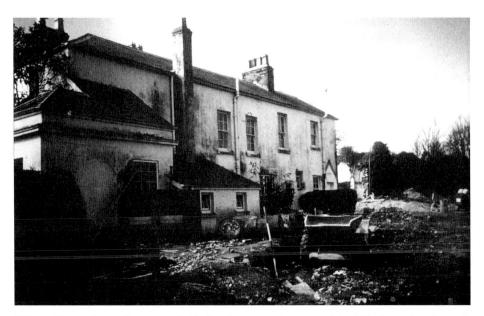

'Mount Pleasant' was the name of this farmhouse on the crest of the hill above the village. It still bore this name in 1783 when the Hurst family held the manor of Dinas Powys, but under their successors, the Lees, it was extended to face the Common and became 'The Mount' or 'Mounthouse'.

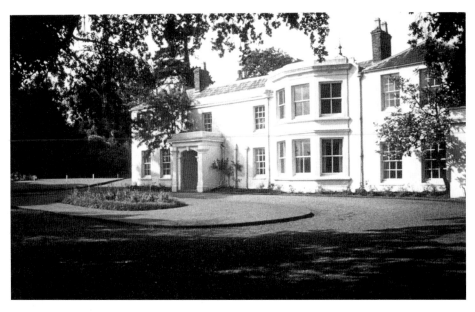

'The Mount'. This is the attractive south wing which became the principal part of the manor-house. Herbert Henry Lee was born in the room above and to the left of the porch, on 4 October 1838. He was the eldest of the ten children of Revd Henry Thomas Lee, Rector of Wenvoe, but resident here at 'The Mount'. The family left the village in 1934, and Selwyn Martin bought the house. Despite several changes of ownership, 'The Mount' appears unchanged externally but now forms several flats. When this photograph was taken in the 1970s, builders' markers to the left indicated where a small estate of bungalows by Hird and Brooks was to spring up within the boundary wall.

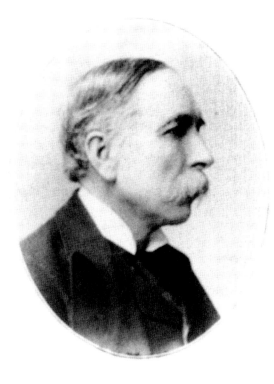

Major-General Herbert Henry Lee CBE, DL, JP in 1907. His name repeatedly occurs in any account of Dinas Powys in the past century. He was educated at Marlborough, King Edward's School, Bury St Edmunds, and Addiscombe College. He was commissioned in the Bombay Engineers of the East India Company before transferring to the Royal Engineers. He saw service with General Roberts at Kabul, in Abyssinia, and in Egypt, before his wife's ill-health led him to retire from the Army with the rank of Major-General. Throughout his military career he took a keen interest in the welfare of troops and civilians, serving on the Indian Famine Relief staff in 1878 and encouraging temperance among the other ranks. He had succeeded his father as Lord of the Manor in 1876, and on his return to Dinas Powys he took a keen interest in all aspects of village life.

This memorial to one of General Lee's favourite pets was fixed on the wall alongside the Mount coach-house. (There was also a pets' cemetery on the edge of the wood behind 'Bryneithen'.) To the villagers it seemed quite natural that they should touch their caps, and that their womenfolk should curtsey, as 'the General' drove through. He served the Church as warden and licensed lay reader and on various committees, and was elected to the chairmanship of both parish and rural district councils. He was Deputy Lord Lieutenant of Glamorgan and patron or president of almost every organisation in the village and many beyond. He gave land for the churches and chapels and sports clubs and there was genuine mourning at his death m 1920. In a memorial sermon the Bishop of Llandaff spoke of his 'devotion to the good cause of the welfare and uplift of his fellow men' and though the General was sure that he knew what was best for the village, Percy Randell could describe him as an 'aristocrat but no autocrat'.

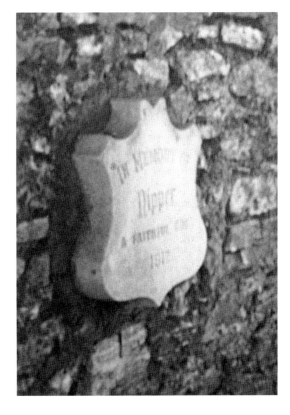

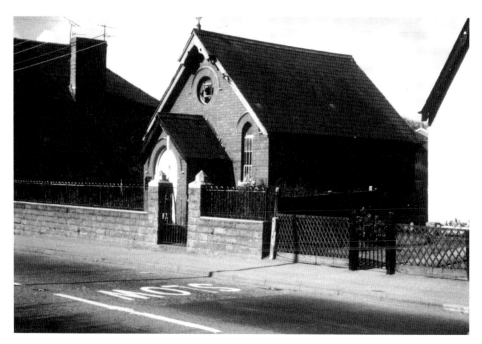

St Peter's Mission Church, Eastbrook, 1975. This was one of the places of worship for which the General gave the land, and it served the railway community of Eastbrook until its conversion into a modern house in 1976.

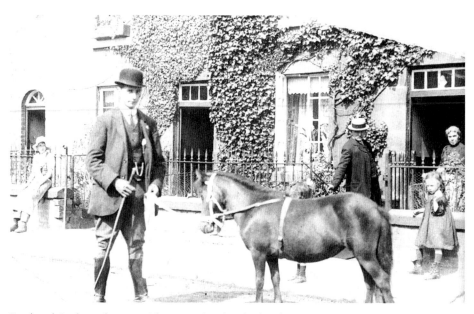

Eastbrook in the early 1900s. The Evans family, who lived just past The Swan – Gwilym with the pony, grandparents Owen and Sarah Evans. Eastbrook used to be regarded as the poorer area. Its name 'The Holes' may have referred to the many ponds in this often-flooded area, and Eastbrook children, struggling to school when 'the waters were out', had to be provided with hot meals.

The Swan Hotel, Eastbrook, was a familiar building on a very dangerous corner as traffic increased on Cardiff Road. It was demolished but rebuilt under the same name, further back from the road.

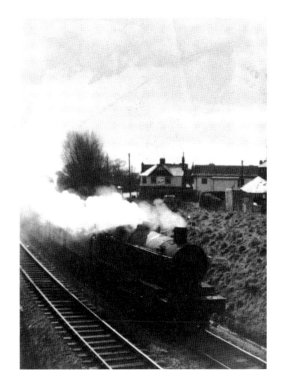

Here an ex-GWR tank engine is passing the old Swan Hotel, 25 March 1964.

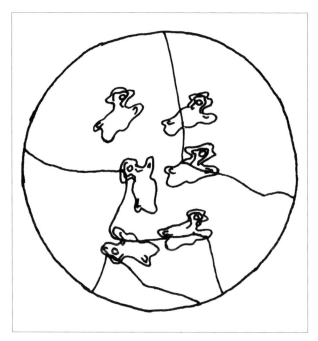

Find from the excavations, 1954. Across the fields from Eastbrook the last of these old villages, Michaelston-le-Pit, has within its boundaries one of the oldest settlements in the area – the hill-fort excavated by Leslie Alcock in 1954. This was revealed as a centre of considerable importance, the seat of local chieftains and inhabited from the fifth to the twelfth century. Among the finds were fragments of the first bowl stamped with animal ornament to be found in the British Isles. The homely rabbit decoration (described by the archaeologists as 'running felines') has been reconstructed here in a sketch from *Y Chronicl*, the magazine of Dinas Powys Local History Society.

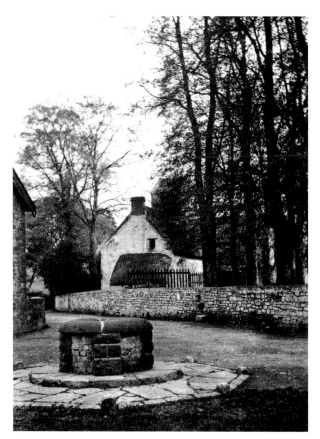

The Wellhead, Michaelston-le-Pit, *c.* 1900. This village, in Welsh 'Llanfihangel-y-Pwll', derives its name both in English and Welsh firstly from the dedication of the parish church to St Michael and All Angels and secondly from its situation in a natural hollow in which the Bullcroft and Wrinstone brooks join to form the Cadoxton River, which flows through Dinas Powys as the Mill Brook. Later a pump was added to the village well.

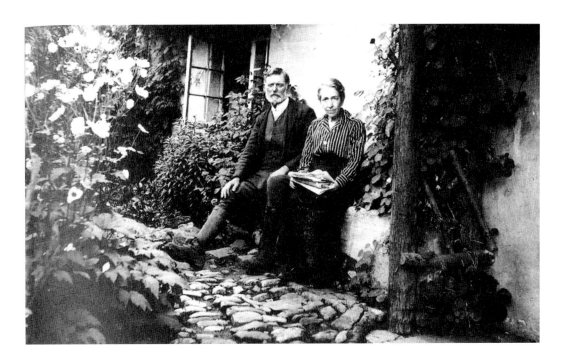

Mill Farm, Michaelston. Thomas Hopkins, seen here at the farmhouse with his wife, Elizabeth, farmed here at the beginning of this century. Their sons, Ivor and Fred below are preparing to cut hay in Ten Acre Field at the bottom of Wrinston Lane. Ivor is operating the hay-cutter drawn by the horses, Duke and Jake, while Fred stands ready with the hay-rake. This was before 1914 when they both left the farm for 'Kitchener's Army' (see p. 96a).

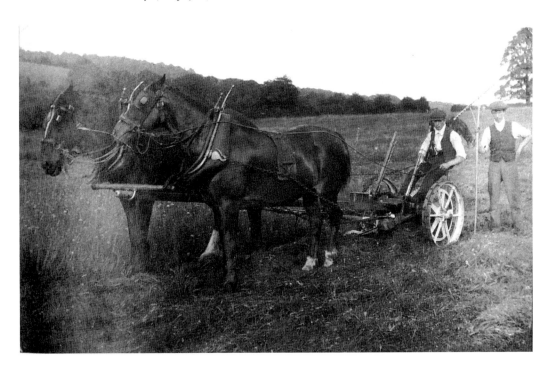

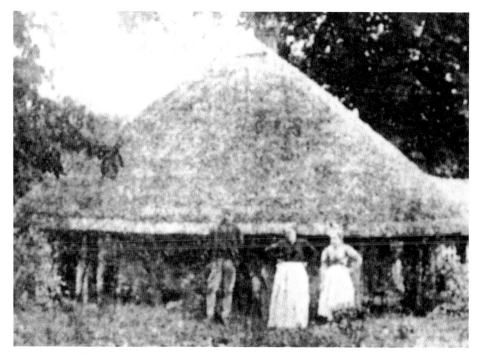

The Round Lodge, 1900. Mrs Elizabeth Williams and her daughter, Lizzie, stand outside the unique round lodge at the Caerau entrance to the Cwrt-yr-Ala Estate. This was a survival of a primitive type of house built in the Welsh countryside since prehistoric times. It enjoyed a revival of interest during the cult of the 'Picturesque' but could be smoky and draughty. It was destroyed by fire as were so many ancient thatched dwellings.

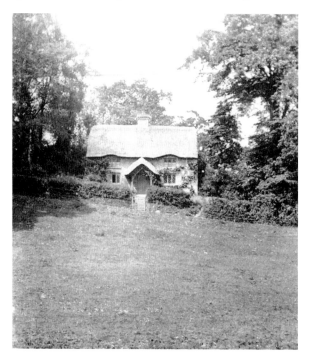

Coachman's Cottage, before 1914. This thatched cottage was distinguished by its old-style central chimney and thatched porch. Locals accounted for an extra window pierced in the side wall as allowing the coachman to 'lie-a-bed' and watch his men exercising the horses. In front of the cottage the land dropped down to Cwrt-yr-Ala Ponds.

At the Bullcroft before 1914. This was the home of Llewellyn Williams and his family. He had been brought up in the Round Lodge but on his marriage moved to the Bullcroft and enlarged it for his growing family.

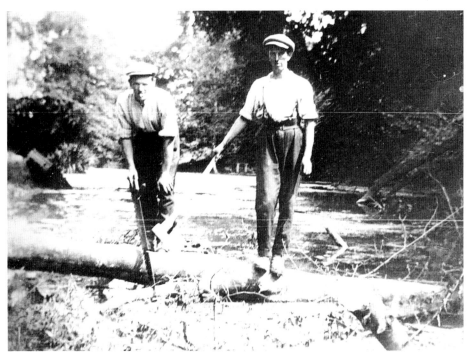

On the Cwrt-yr-Ala Estate after 1918, Llewellyn's son, Aneurin Cadwaladr (universally known as Dick) worked on the estate both before and after the First World War, in which he served in the Royal Artillery (see p. 98). He is at work here with Fred Hopkins clearing the Dairy Pond.

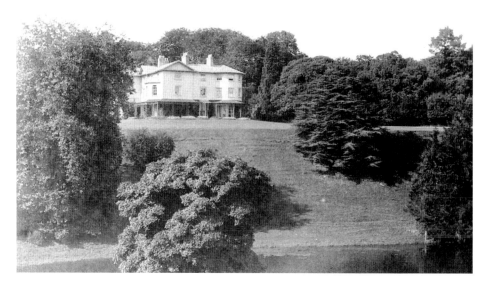

Cwrt-yr-Ala House, *c.* 1910. Built in 1820 by Edward Haycock of Shrewsbury, this mansion stood above a magnificent series of artificial lakes. The house was enlarged in 1850 and 1876, and was the home of the Rous and Brain families before its demolition in 1939. Sir Herbert Merrett, the new owner of the estate, commissioned Sir Percy Thomas to design a stark white house in its place.

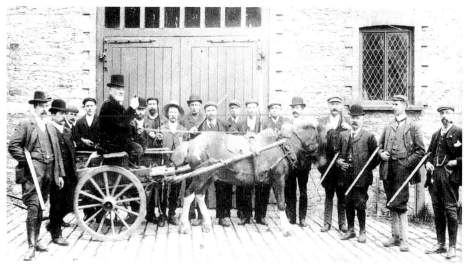

The Rook Shoot, Cwrt-yr-Ala, 1908. This was an annual event, much enjoyed by the schoolboys who followed the guns and gave the schoolmaster more cause for complaint about non-attendance. Edwin Williams was the keeper on the estate, and here he is organising the shoot from the trap he had built himself. Also in the picture are John Rees (in the straw hat) and besides him, gun on shoulder, Mr Morgan (their son and daughter were to marry in later years, see p. 51b). Evan David from Penylan Farm and Mr Bond, the Canton blacksmith, have also joined the estate workers for the shoot.

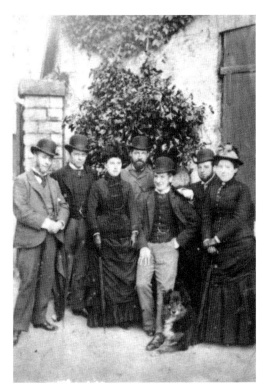

Mrs Rous's staff at Cwrt-yr-Ala, pre-1914. Jenkins the coachman is by the dog, and on the left is Moore, the butler, about whom many tales circulated in the village. Probably the best was that he was left a legacy by Mrs Rous – £1 a week – for caring for her pet dog, Bobs. It was noticed that Bobs never died – Moore had enough replacements to keep the dog going as long as he did!

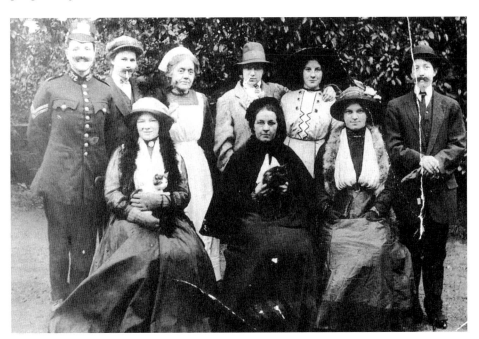

Mrs Brain's staff at Cwrt-y-Ala, 1914. Their successors have turned out in fancy dress for this photograph, this time with pet cats. Only the nanny, third from the left, back row, looks really authentic – and has not dressed up for the part.

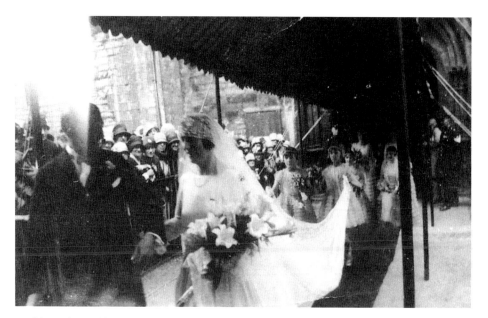

Wedding of Ronald Scott Sugden and Helen Mary Brain at Llandaff Cathedral on 2 June 1928. When the daughter of the house, Molly, married at the Cathedral, an open charabanc was hired to bring all the Cwrt-yr-Ala staff to the wedding. They were photographed on the Green at Llandaff. Dick Williams stands in front with Mr Lockyer, the gardener. On board, from left to right at the back: Mr and Mrs Williams, Kitty Hopkins, Gladys Morgan, the two Randell boys and their mother, Gertie Williams, Muriel Moore, Mr and Mrs D.R. Morgan. In front: Peggy and Gwyneth Walker, Mrs Hamilton, G. Williams and Mrs Rainer.

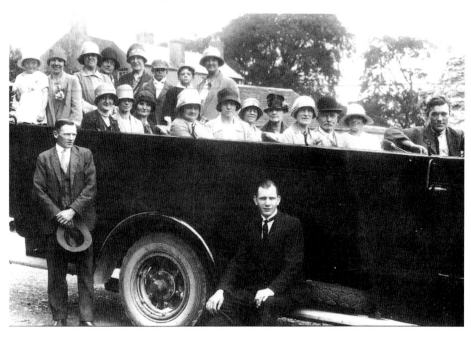

The parish church of St Michael and All Angels dates back to the fourteenth century. It is cruciform in shape with tiny transepts under lean-to roofs. The saddle-back tower contains only one bell (the other was stolen in 1769). The tiny nave is dominated by a large version of a three-decker pulpit, the only one left in the Diocese of Llandaff.

Both St Michael's and St Peter's, Old Cogan, have retained in the porch a pre-Reformation stoup. Here Mrs George Thomas demonstrates its use when it was filled with holy water for worshippers to make the sign of the cross before entering the church.

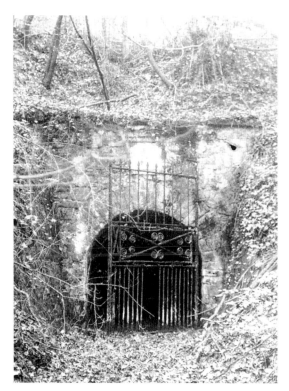

The iron mines, pre-1914. This part of the old workings was beyond Cwrt-yr-Ala and between Caerau and Wenvoe. Ore was extracted and sent via Wenvoe to Cardiff, but the high phosphorus content meant it was useless for the Bessemer method of steel production which predominated in Glamorgan ironworks from the mid-1860s and by 1868 the workings had been abandoned. The entrance had been rebuilt in 1805 and early in this century the weighing-house and blacksmith's shop could still be seen.

The Cwrt-yr-Ala Ponds, *c.* 1910. In the background is old Cwrt-yr-Ala House. The otter-hunt took place downstream from the ponds, which remain places of private beauty.

Two

Schooldays

There had been several attempts at education in Dinas Powys before the opening of the National School in 1858. One of Griffith Jones' circulating schools met in 1745-46 in the porch at St Andrews, or possibly in the upper room of a poorhouse which stood in the churchyard. William Thomas, the diarist, may have been the master. What was later the coal-house of the Rectory was used at one time for a school. In the village there were dame schools, in Eckley Cottage, and in Rose Cottage in what later became known as Station Road. John Rowlands was teaching in the village in 1856, perhaps in preparation for the building of the National School. Its first pupils came from a school that had been held in the outbuildings of Mount Farm and later in the carpenter's shop behind The Star. Despite the continuation of small private schools which catered mainly for the sons of the richer farmers, most of the village children received their education from the Church in the National School until the opening of the first non-denominational state school – the Council Schools on Cardiff Road – in 1909. After the First World War the Red Cross Hospital was converted into St John's School, later St Winifred's. The most successful of the private schools was St Anne's 24 Millbrook Road (1936 to 1965). Apart from the village was the Cardiff and Barry Truant School opened in 1899 reorganised as an industrial school in 1910, and from 1933 as Brynydon, an 'approved school' which closed in 1979. Of these, it was the National School which was at the heart of the village, which lost something precious when the children were transferred, of necessity, to a modern school building at the end of the Common in 1971. We know more of the National School than of any of the others, as the National Society (which put up half the cost of the original building) stipulated that its schoolmaster keep a daily record. The existing Dinas Powys School logbooks open in 1874 and routine reports of the weather and visits of inspectors are enlivened by remarks like that of 6 October 1874: 'The prevalence of the use of Tobacco obliges me to search the children's pockets and confiscate their pipes ...'. Or, in 1898: 'Owing to the visit of Barnum's Show to Cardiff ... the attendance fell off considerably'.

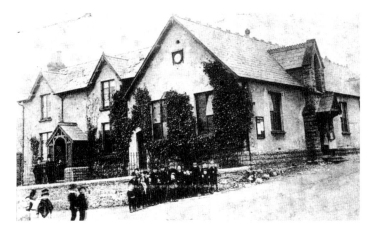

The National School, Dinas Powys, *c.* 1895. The schoolroom was built in 1858 to accommodate 170 children; an additional classroom (on the right) was added in 1885, a year after places had been refused to twenty-four children from Michaelston because of overcrowding. The Rector, probably Revd H.J. Williams, stands with the schoolmaster by the porch of the Schoolhouse.

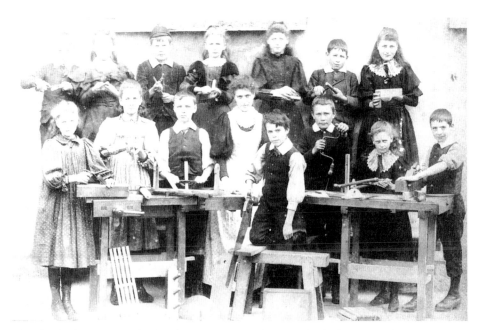

The Sloyd Class, National School, *c.* 1898. The Sloyd method of teaching 'handwork' was introduced in 1887. The teacher was Mrs Mockford, wife of the headmaster, and teaching was carried on in the 'Sloyd Shed' in the playground. Billy Randell takes centre-stage with the saw, and a future headmaster, Heurtley Newnham Rees, who entered the school in 1895, may be one of the pupils with a circular ruler.

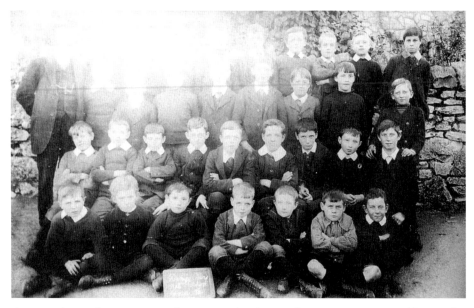

Group IV boys, after 1904. Howell Jones was headmaster from 1904 to 1933 and he is still a young man in this picture of pupils in their Eton collars and long socks. The group has been identified on the slate but not, alas, the date.

National School staff, *c.* 1918. Howell Jones sits among his staff. The young man is H.N. Rees, known affectionately to the whole village as 'Nut'. An old boy of the school, he was the second to win 'a bursary at the Penarth Grammar School', and he returned in 1918 as a certificated assistant. After moving to teach at Penmark, he returned in 1933 to succeed Mr Howell Jones as headmaster and to dominate life in the school and village until his retirement in 1958.

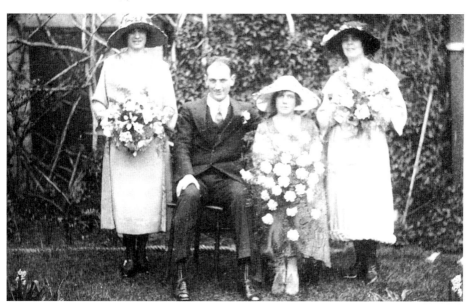

The wedding of Mr H.N. Rees and Miss Annie Winifred Morgan from Highwalls Road on 3 April 1923. The bridesmaid on the right is Miss Gwen Rendell, on the left, a cousin of the bride. 'Nut' Rees took the lead in most village activities and was widely respected. A window behind the font in St Peter's was given in his memory. Mrs Winnie Rees was also a leader in her own quiet way, giving years of service to the Red Cross and becoming the local commandant. For twenty-five years she was chief of the voluntary librarians, retiring in 1957.

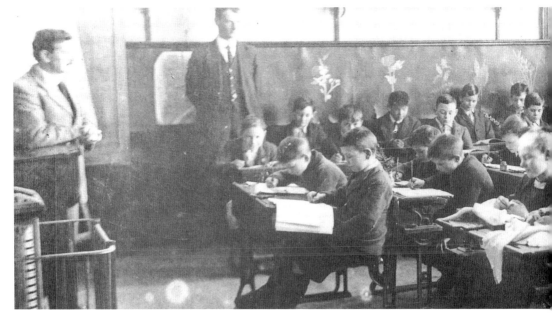

Inside the original schoolroom, early 1920s. Built in 1858 and little changed, this was a typical schoolroom of its day with its high windows, dark dado decorated with nature paintings, and iron stove. The headmaster, Howell Jones, is at his desk and the class are also being supervised

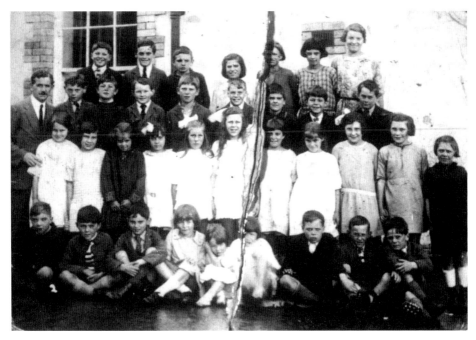

National School class, c. 1926. In this group Howell Jones stands next to his son (second row, extreme left). From left to right, back row: Reggie Hill, Tony Dunford, Bunny Miller, ? Hartrey, ? Williams, Grace Miller, Grace Hill. Middle row: David Howell Jones, Billie Sutton, Billie Hoosen, Ernie Spear, Jack Ridout, Arthur Miller, Lee Mason, Billy Harry. Front row, sitting: Mervyn ?, Jack Bevington, three girls not named, Tommy Bishop, Howard Davies.

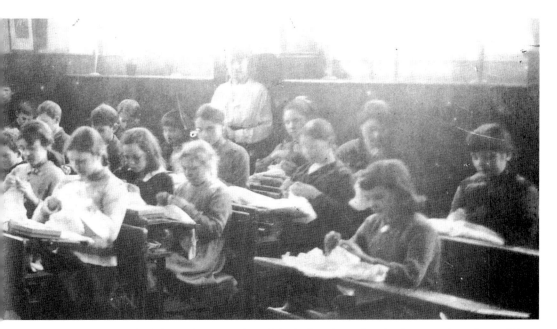

by H.N. Rees and a lady teacher. Note that while the boys have their books open, the girls are all busy with needlework.

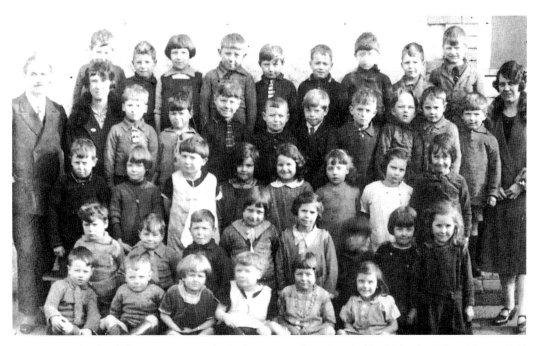

National School class, *c.* 1930. In the back row: Beryl Davies, Gethin Richards, Jeffrey Hussey, Enid Prosser, Brinley Richards, ? Ponsford, Douglas Clayton, Jack Deeley, Miss Williams, ? Curtis, Neville Gadsby, Reg Southcott, -?-, Jimmy Hill, Alfie Hall, David Dunford. Robert Marne, -?-, Joan Richards, Joan Davies, Doreen George, ? Ponsford, -?-, Muriel Gadsby. Kenny Britten, Rowland Shellard. -?-, -?-, Dulcie Davies, -?-, Doreen Nation, Enid Fouracre. -?-, -?-, ? Richards, Connie Griffiths, Rosemary Pearce.

Demolition of the National School, spring 1971. The old building was too small and was judged unsuitable for modern teaching methods, so the decision was taken by the diocesan authorities to demolish the old building and erect a new one on a larger site. The old bellcote was the last to go, but the bell still rings in the new school. A housing development of two-storey flats, Britway Court, was erected on the old site and special care was taken to echo the lines of the schoolhouse with its gables in the new building.

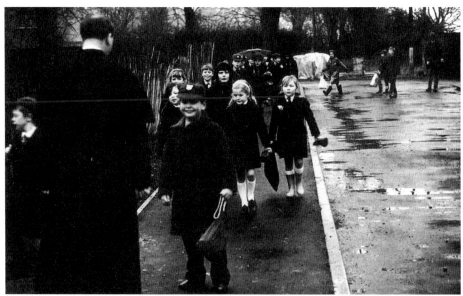

Welcome to the New School, March 1971. The Rector, Revd John Lloyd Richards, welcomes pupils to the new St Andrews Church-in-Wales School in front of 'Bryneithen' on St Andrews Road. The headmaster, David Southall, brings up the rear. The new school was built on an open plan and in the grounds there is room for ample playing fields and a nature cabin. This generation of children wear uniform.

Council School scholarship children, 1927. A state elementary school was opened on the corner of Cardiff and Murch roads in 1909. Although General Lee referred to it in private as the 'spite school' (seeing the government policy of non-denominational schools as a blow to the Church), he was generous in awarding prizes for housewifery. Mary Shepherd (see p. 112) was a prize-winner and spent her £5 on a smart new coat. Pupils from Dinas Powys were eligible for scholarships (the old eleven-plus) to both Penarth and Barry grammar schools and these scholarship winners for 1927 include Dora Lewis, on the right in front.

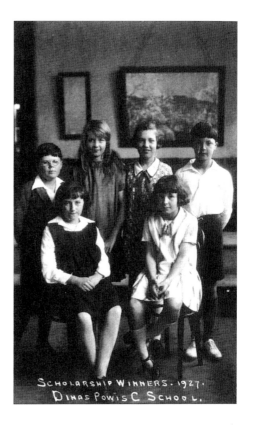

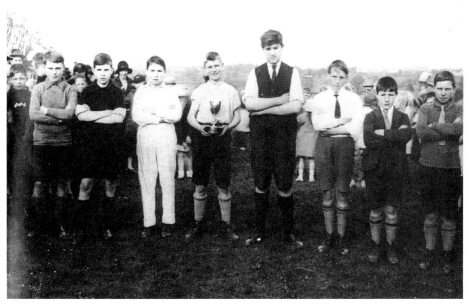

Council School winners of the tug-of-war at the Empire Day Sports, 1925. From left to right: R. McPherson, F. Cottrell, M. Evans, A. Orphin, A. Salter, C. Walker, D. Walker, E. Cox.

Lodge and Gateway to Brynydon School. Boys from the school in their grey uniform jerseys, shorts and socks, and red and grey horizontal striped ties, were a familiar sight marching in a crocodile through the village, and took part in the first Remembrance Day Parade in 1923 (see pp. 102-103). The school closed in 1979 and the gateway and lodge were demolished shortly afterwards. 'Brynydon' has now been renamed Hebron House and a purpose-built home for old people has been erected in the grounds.

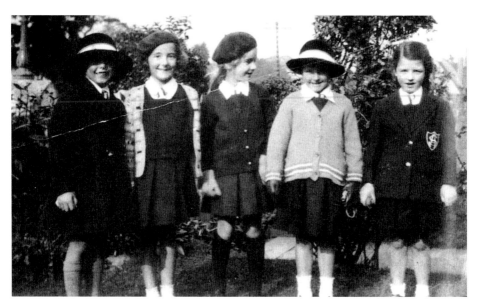

Pupils at St Anne's School, 1937. In the summer of 1936, St Anne's School was opened at 24 Millbrook Road by Miss Lucy Hardman and Mrs M.F. Scott, who had trained in the Froebel Institute and used their advanced methods of teaching. It opened with two pupils and the numbers began to grow when this picture was taken in the following year. From left to right: Angela Everett, Daphne Beveridge, Jane Jacob, Diana Birmingham and Chrystal Tilney.

Three

Farms and Farming

Farming was the chief occupation in these villages from prehistoric times almost to the end of the nineteenth century. In 1789 Iolo Morganwg described Dinas Powys as standing 'at the north end of a fine even plain of excellent soil, where the inhabitants keep their sheep and other cattle ... to the south there is a fine view of small hills, vales, woods, rich meadow and cornfields'.

This tradition of mixed farming continued, and the varied nature of the farmland was noted by John Rowlands, the village schoolmaster, in 1856 – 'wide marshes unknown to the merciless plough extending to the sea and fields crowned with fruit and crops and the oxen grazing in the adjacent green meadows'. The mention of oxen is significant. Rowlands was gazing from the Bishop's Seat across Cadoxton Moors to the sea. Oxen were habitually used to draw the ploughs on the open fields. Where the land was drained villeins had farmed the open fields of the manor in Norman days, and the distribution of the long narrow strips of land can still be seen in the hedgerows (see p. 19).

Well into this century even those villagers not employed on the farms could not but be aware of farming tasks. Cattle and sheep were driven through the village, horses were the most familiar form of transport until well into the twentieth century, and the smells and the sounds of the country were all around. Before the Second World War the pupils from the Council School were given a half-day each summer to turn the hay in the Mill Fields. The recreation of village children was to watch the sheep-dip and shearing, to drive the cows or ride the great shire horses and to watch with horrified fascination the killing of the cottagers' pigs!

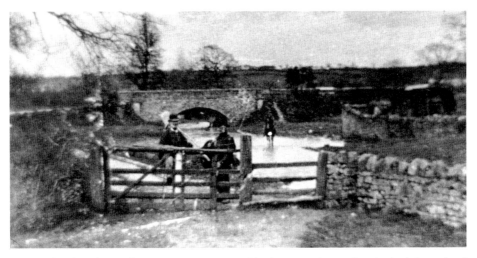

The Ford and Bridge, Mill Farm, 1870s or 1880s. The horseman is crossing the ford that existed long before the first bridge was built on the road from Cardiff over Penyturnpike to Dinas Powys village. The distance is empty of houses except for the few in Elmgrove Road that were marked on the 1885 Ordnance Survey map. To the right across the Mill Brook is the yard of the Mill Farm, and two venerable characters have paused for a chat at the gate into the Mill Fields.

Biglis Farmhouse near the site of Biglis Court (long demolished). Biglis Court once stood on the corner of land near Biglis Bridge, but when the bridge was demolished the Cadoxton link road was constructed across the remains of the Court. To the north are traces of rural settlements dating back to the second century BC and farmed until the fourth century AD. The archaeologists' description of the settlement as a 'patchwork of fields, open pasture and managed woodland' has a familiar ring. Across the fields towards Coldbrook stands Biglis Farmhouse, erected *c.* 1630. The wooden Tudor arch over one doorway is reminiscent of the chimney arch in Old Court (see p. 21). The present owners have faithfully recorded and, where possible, preserved timber mullions, oak beams, ingle-nooks and a bread oven.

Demolition of the Malthouse. The Malthouse was another old farmhouse (see p. 34a) with its own brew-house in the outbuildings. Mr R.W. Hall photographed it prior to demolition and noted the ancient cruck, rare in this part of the country. Curved tree trunks were split in two and the parts rested against one another at the top to support the roof. A second cruck can be glimpsed through the doorway.

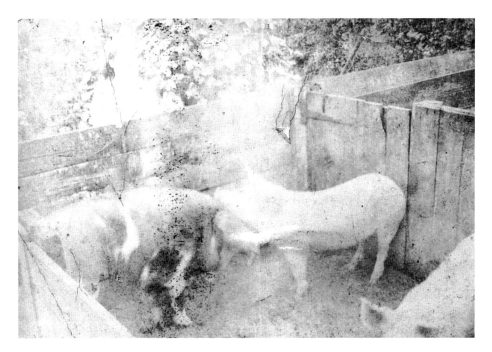

Feeding the pigs, *c.* 1908. The pig was greatly prized by cottagers, for every part of it could be used. Most families kept a pig at the bottom of the garden or across the yard. Miss Gwen Randell retained a vivid memory of seeing (and hearing) Edward John killing his pig on the wide stretch of road at the top of Broth Lane. Here Flo Bevington is admiring the pigs in the yard behind The Star.

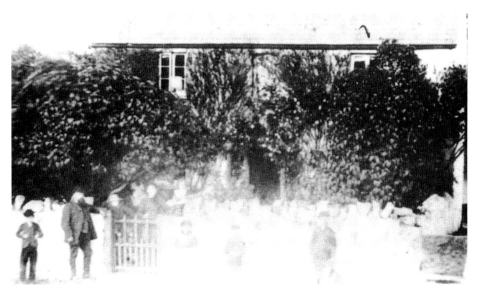

The Old Mount Farmhouse which was situated in the village itself, its yard across the road and its barns beside the Common. This was the appearance of the farmhouse when Morgan and Mary Williams first lived there – a modest building with rooms on either side of a central door and staircase. As their family grew to nine children, they added interconnecting rooms as needed.

The Commoners' Trees. One tree was planted here on the edge of Dinas Powys Common for every farmer who could claim rights to pasture his sheep, goats and geese. Commoners included Claudy of Glebe Farm, St Andrews; Williams of Mount Farm; Meredith of the Malthouse; Harry of Southra; Morgan of Westra Fawr; the Rector; and the Lord of the Manor. Sadly, the clump was decimated by Dutch elm disease, but has been replanted. To the right is the new Mount Farmhouse but the farmyard and barns became derelict during the Second World War, and new houses were erected there. Directly behind the trees is the Wesleyan Chapel built in 1876 but superseded by the connecting building in Station Road. To the left of the chapel is 'Kynance', a Georgian building, once the Methodist Manse and later a youth centre.

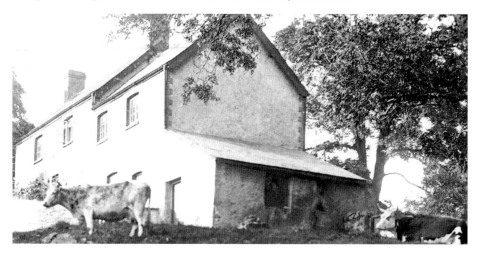

Ty'n-y-Coed, c. 1900. The photographer has captioned this in error as Highwalls Farm, but 'the house in the wood' has changed little over the years and is clearly recognisable today. The slope was steep for cattle, but it was an ideal vantage point for Mr Hamilton the gamekeeper after whom it was known as 'Keeper's Cottage'. From here he could watch the village boys attempting to tickle trout along the Mill Stream and he kept a silver whistle to warn them off as he stood by his house, shotgun over his arm.

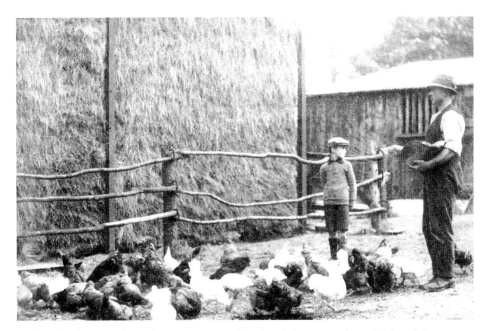

Feeding the hens on the Mill Farm, *c.* 1900. The Dutch barn, seen here filled with hay, was a distinctive feature of the farmyard in front of the Mill. Many of the old farm buildings and even the houses were not glazed but had windows with parallel wooden mullions like that shown here. There was a similar mullioned wooden window in the Argae barn before conversion.

Entrance to the Mill Farm, *c.* 1900. The end of the Dutch barn and of the Mill itself are on the right, and in the middle distance the Mill House with Dinas Powys Castle above and beyond it. The bard, Dewi Wyn o Essyllt (Thomas David), worked with his father and lived here and at The Three Horse Shoes before moving to Pontypridd in 1874.

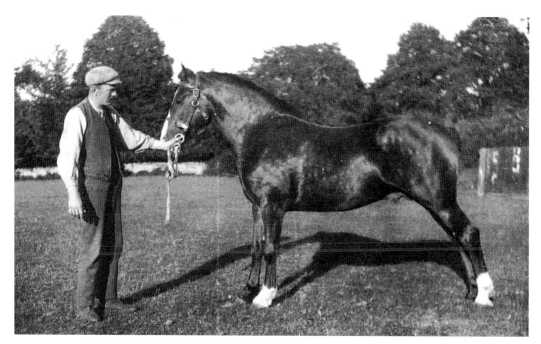

David Howell Thomas of Highwalls Farm, *c.* 1910. Since 1914 the golf club and clubhouse have occupied the fields of Highwalls Farm and the farmhouse. At one time it was the dwelling of the Constable of the Manor appointed by the Court Leet. When this photograph was taken before the First World War, the farmer was David Howell Thomas, seen here showing his stallion.

On Highwalls Farm, *c.* 1910. The houses of Old Highwalls can be seen in the centre across the fields, and building has extended only halfway up Highwalls Road (or Avenue).

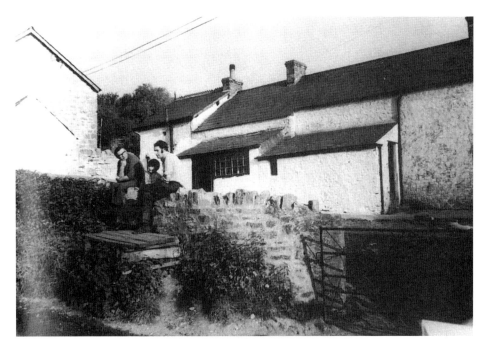

Cross Farm, photographed in the 1970s not long before its conversion from farm buildings to a modern dwelling house. Against the wall where the men are resting is the wooden platform for the milk churns, a familiar sight on every dairy farm before the days of milk-tankers, when the churns were collected by open lorries.

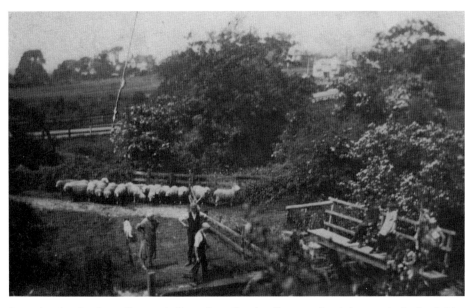

Preparing for the sheep-dip, 1938. Sheep from Southra Farm are herded towards the footbridge below Wellwood Drive. The space beneath the bridge had concrete walls and slots for planks to dam the stream. Mr Harry is checking the water-level.

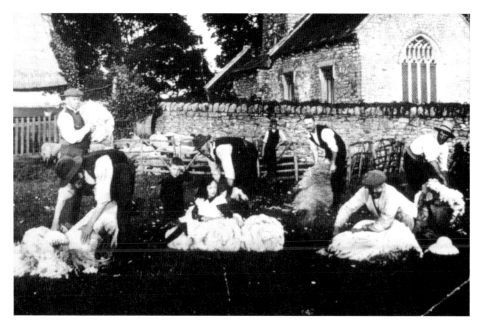

Sheep shearing at Michaelston in 1914 on the fields of Tile House Farm close to the church and thatched cottage. From left to right: J. Moore (standing), John Thomas (shearing), Harold and Gwen Davies with Thomas Hopkins behind, J.D. Davies (by the sheep pen), Bill French, A. Moses and J. Pope (shearing).

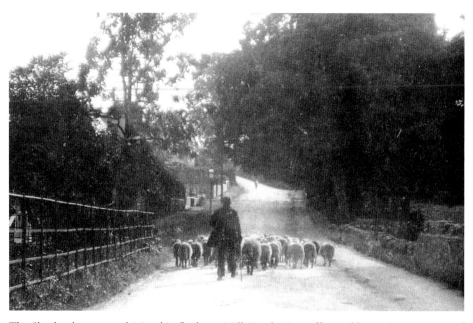

The Shepherd, c. 1900 driving his flock up Mill Road. No traffic problems! An evocation of Dinas Powys as a farming community.

Four

Other Occupations and Professions

In the notes he prepared for his lectures on old Dinas Powys, Percy Randell recalled the tradesmen and craftsmen he had known in his boyhood and of whom the old men had told him. He evoked memories of the village before the coming of the railway – 'We were a busy little community even in those far off days. Farming was of course the chief industry, cattle rearing, sheep farming and wool collecting. The last weaver worked in a small cottage in Heol y Cawl. The milling of flour and the crushing of corn for cattle was done at the old Water Mill near the Castle. There were a dozen stone quarries and quite a number of lime-burning kilns. There were estate woodcutters, thatchers, carpenters, stone-masons, generally a resident tailor and bootmaker, butchers, bakers and grocers. Here also was a wheelwright's shop and the blacksmith who not only made and fitted horse shoes and fixed metal tyres to wheels, but also made gate hinges and fastened nails and bolts and repaired agricultural implements. Hawkers supplied paraffin for house-lighting and pots and pans, kitchen utensils and brushes. Pedlars brought ribbons and tapes, cotton, laces and light haberdashery. These people were the bearers of news from village to village. Muffin men complete with hand-bell and arm-basket lined with clean linen were regular callers, and milk was delivered by men and women who carried milk pails suspended from wooden shoulder-yokes'.

Improved communications by rail after 1888 changed many things, but for a generation the old country ways and the modern world of docker and navvy existed side by side. News came now by telephone and telegraph and most people could afford a daily newspaper – and read it. The milk came in churns not pails, and local haberdashery shops replaced the hawker and pedlar, but as late as 1942 the carrier passed through the village each week. Local men whose fathers had worked with horses turned their hand to a different kind of transport, and the blacksmith evolved painlessly into the garage mechanic.

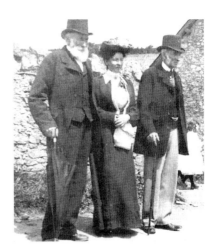

Representatives of two worlds and two social classes of Dinas Powys mingle at the same country event in the early 1900s. Radcliffe, the shipowner (right) with side whiskers and a natty turnout is in striking contrast to the patriarchal figure of Morgan of Westra Fawr. He was one of the leading farmers under whose patronage a dairy class functioned at the National School during the summer holidays. A staunch Nonconformist, he was quite prepared to stand up to the General on matters of religion or common rights.

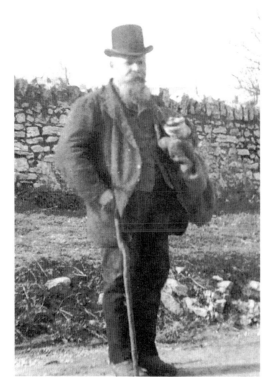

Williams of Mount Farm was overseer under the old Parish Vestry and rate collector under the new Parish Council after 1894. Farming duties done, he would set off after tea with his Gladstone bag under his arm to start on his round of rate collection.

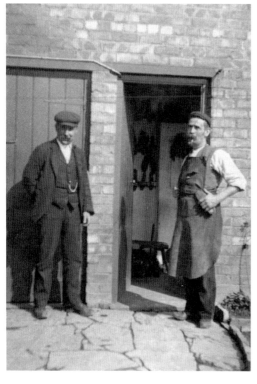

Gardener and shoemaker caught in conversation at the back of the shop in Station Road where the Misses Clare and Myfanwy John ran a shoe shop until about 1960. Fifty years earlier, their father, Thomas John, is pictured in his cobbler's apron by the open door of his workroom. Inside are his three-legged stool and the tools of his trade. Beside him is William Pugsley, head gardener at 'The Mount'.

Woodcutter and handyman, Morgan or 'Mog' Miles worked on the Mount Farm and lived in Britway Road. Bill-hook in hand, he has just crossed the road from the Mount Farmhouse to its yard, with The Star Hotel in the background. He is lurking behind the first car in Dinas Powys (see p. 85).

(see p. 85)

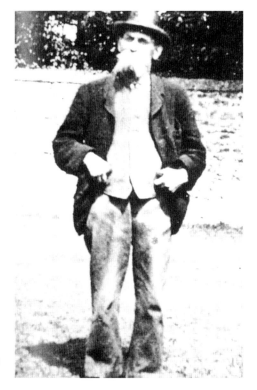

'Two o' Rum', the roadmender. Davy Edwards was employed by the Bute Estate to maintain the road from Cogan Hall to Lavernock. He was famed for his skill in answering the rhymed verse of the Mari Llwyd when 'she' came to the door at Christmas and the New Year, but his notoriety sprang from his habit of rushing into The Star with the invariable demand, 'Quick, in a minute! Two pennorth o'rum!' Roadmending was dusty and thirsty work in the days before tarmac!

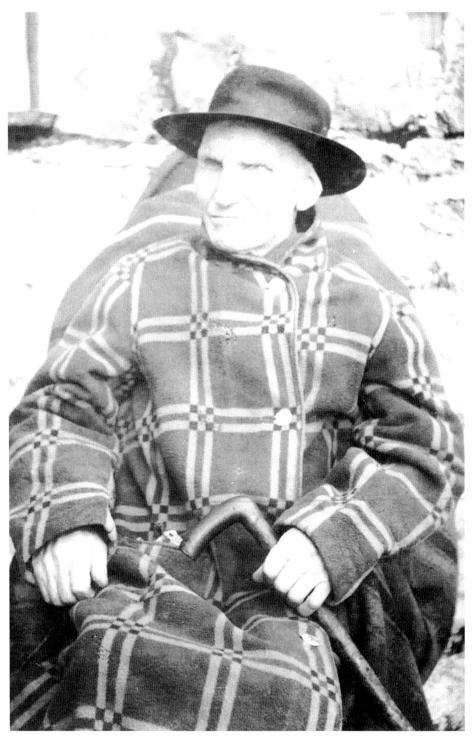

Roadmender in old age. 'Daddy' Edwards had also been a roadmender but a very different character is shown in this study of old age taken by Percy Randell.

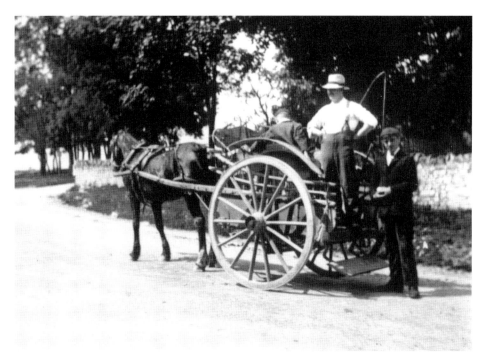

At the Mount Corner, *c.* 1900. The Mount Farm milk-cart pauses to give a ride to the Randell brothers, Ted and Percy (standing in the road).

Percy Randell (1886-1966), photographed in 1918. The youth of thirteen or fourteen in the picture at the top of this page has now left school and embarked on the business of optician, with premises in the Royal Arcade in Cardiff. As a schoolboy he became interested in local history and won a guinea in the Dinas Powys Eisteddfod in 1909 for his essay on 'Dinas Powys and its Surroundings'. At the age of about twelve he was given his first camera and with very simple equipment he built up a collection of village scenes and characters, among them the preceding pictures in this chapter. He developed them himself and his artistically-mounted prints and lantern slides are great treasures for the local historian today. Occasionally, he gave lectures to local groups or wrote to the papers to correct or expand on some statement they had published. Sadly, he never wrote up his collection of notes, maps and newspaper cuttings, which included a great deal of information about the Lee Estate. But, above all, in his photographs he preserved for us a village on the verge of change.

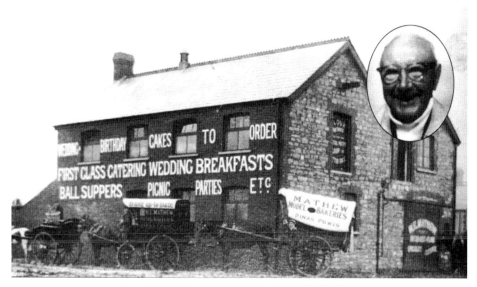

Matthew's Model Bakery, *c.* 1910. This had been built on the corner of Cardiff Road and Greenfield Avenue as a farmers' collective, and then converted to a bakery. At least four carts were used for deliveries and 'wedding breakfasts, picnics and ball suppers' could be catered for! The driver of the cart at the back of the line was Tom Baker (inset) who later started his own bakery in George's Row, Eastbrook. The village long remembered his slogan: 'A Baker Born: The Best Bre(a)d Baker in Dinas Powys'. His son, Gary, used to deliver the bread and a choice of plain or currant buns which he cheerfully offered as 'plain or purl'. As Chairman of the Parish Council and champion of the concerns of Eastbrook, where he lived, Mr Baker was one of the leaders of the community.

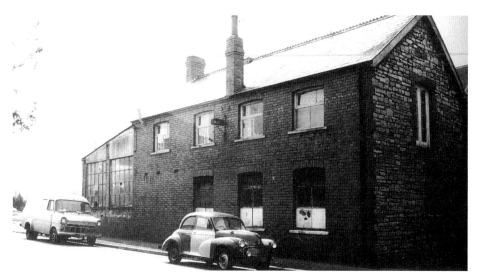

Price's Garage, 1930s. The building was converted into a garage by W.S. Price in 1935 but the bakery signs took years to wear off the roof (see also p. 88). The building had been replaced by a modern petrol station.

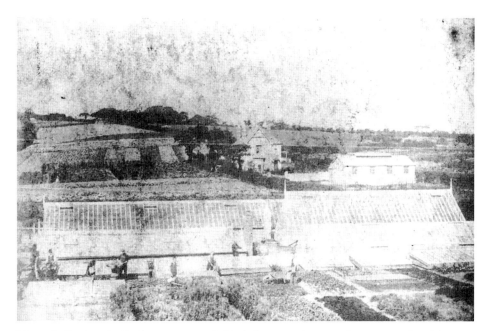

Nurton's Eastbrook Gardens, *c.* 1910. Behind the extensive greenhouses, on the right, was Eastbrook Methodist Chapel, a corrugated iron structure erected in 1899 and administered by Trinity Church, Penarth. In the centre background is 'Oakleigh', the home of Jacob Davies, grandfather of Ivor Novello. Afterwards the Randell family lived there before moving to live close to their sawmill in Broth Lane.

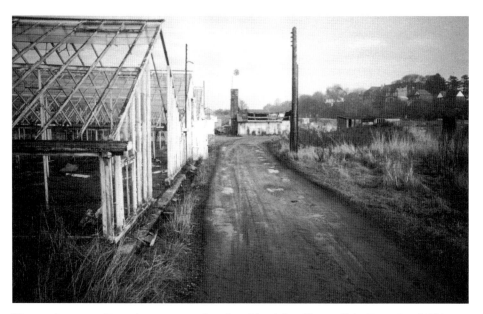

Thurston's nursery, December 1976, on the other side of the village, off the Barry Road. This was close to the site of the old village pound. Wellwood Drive is seen in the distance, right, beyond the glasshouses and sheds on the verge of demolition to make way for the Southra Park estate.

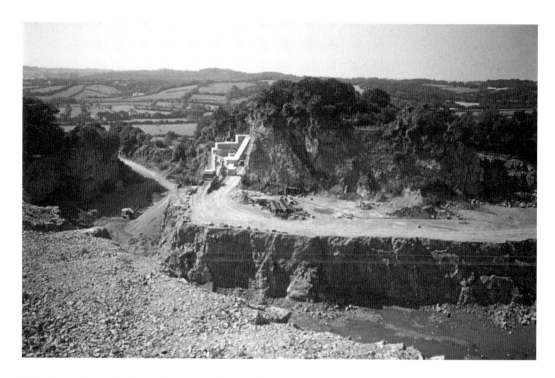

St Andrews Quarry in September 1971 (above) when it was still being worked. The machinery is seen more closely below, in a photograph taken in February 1975 when water was beginning to fill the workings. Between 1922 and 1924, when the quarry was owned by Walter Lewis, stone from here was used to build the new shops and promenade shelters at Barry Island.

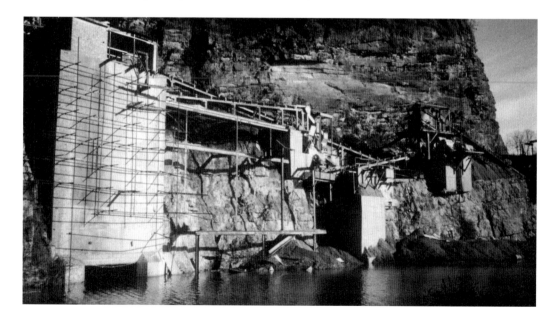

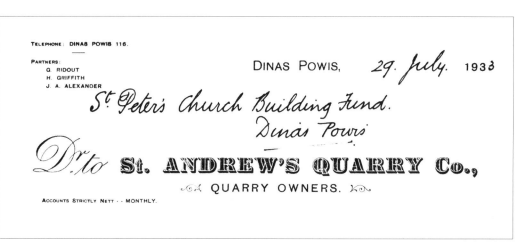

TELEPHONE: DINAS POWIS 116.

PARTNERS:
 G. RIDOUT
 H. GRIFFITH
 J. A. ALEXANDER

DINAS POWIS, *29. July.* 1933

St. Peter's Church Building Fund.
Dinas Powis

D^r to St. ANDREW'S QUARRY Co.,
QUARRY OWNERS.

ACCOUNTS STRICTLY NETT · · MONTHLY.

A 1933 bill-head when the quarry was owned by George Ridout, Harvey Griffiths and J.A. Alexander. George Ridout also had an interest in the lime kilns and workings at Cross Common.

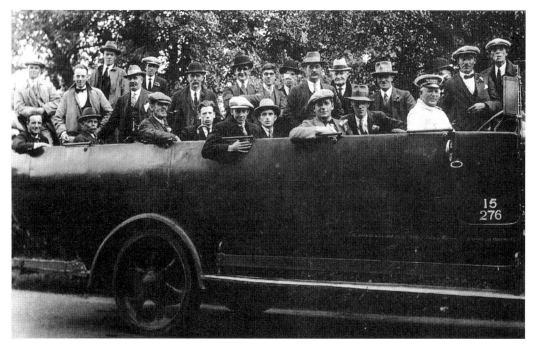

The two groups of employees combined for their annual outings, like this to Banwell in Somerset in 1925.

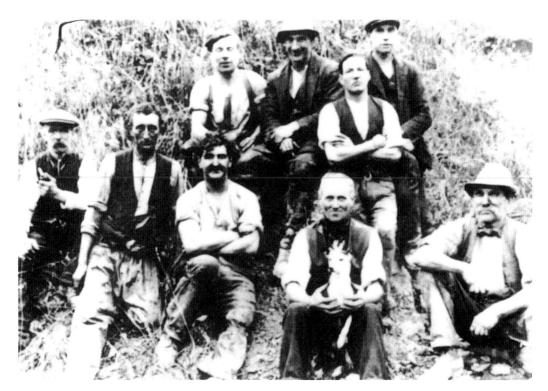

CASTLEWOOD HOUSE, DINAS POWIS

TELEPHONE 38.
TELEGRAMS—RIDOUT, DINAS POWIS

Nov 22nd 1933

Mr Harvey Griffith

Dr. to GEORGE RIDOUT
COAL, COKE, FIREWOOD AND LIME MERCHANT

Contractor for Pitwood to the Principal Collieries in South Wales

GENERAL HAULIER

George Ridout's bill-head, 1933, illustrating his various commercial interests. These bills were all addressed to Harvey Griffiths for work connected with the new church and grounds at St Peter's.

Workers at Westra Quarry, 1930s. This quarry, close to Westra Cross, was owned by Charlie Collins. First on the left is Jim Orpin, and third left, 'Gipsy Jack'. Beside him, Jack Collins is holding the dog, Shep.

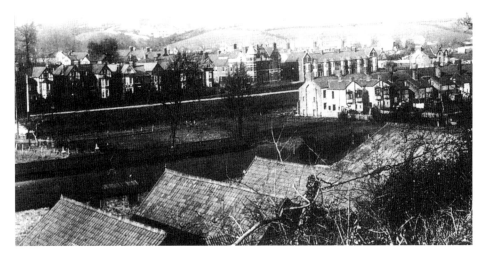

View across the brickyard sheds from the top of the 'cliff' where the clay had been quarried. The Gwalia Brickworks used the local clay to produce the dark red bricks used in Millbrook Road and other parts of the village. Strangely, there seem to be no views of the kilns and stack, which remained long after the works had closed. Compare this with the picture on page 33 taken a decade or so later, when Elmgrove Place (known originally as 'Brickyard Row') had been completed. The brickworks were demolished and the pond filled in, though the offices, seen below, remained as a bungalow until the 1950s.

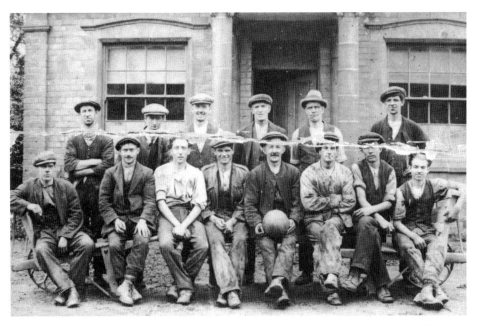

A moment of rest and recreation for the brickworkers in front of the company offices. They are seated on the brick trolleys. From left to right, first in back row: Billy 'Peg-leg' Keen (injured on the railway); fifth: Herbert Cooper (wearing a hat not a cap). Front row, fourth from left: Bill Dunford; fifth: Jim Hill (possibly Merrett), holding the football.

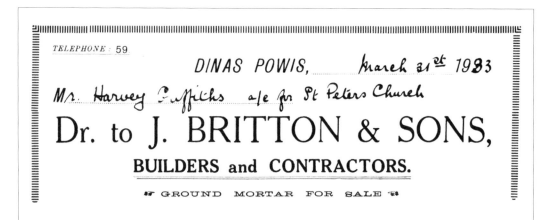

TELEPHONE : 59

DINAS POWIS, March 31st 1933

Mr. Harvey Griffiths a/c for St Peters Church

Dr. to J. BRITTON & SONS,

BUILDERS and CONTRACTORS.

❦ GROUND MORTAR FOR SALE ❦

Bill-head for the local builders and contractors, J. Britton & Sons, 1933.

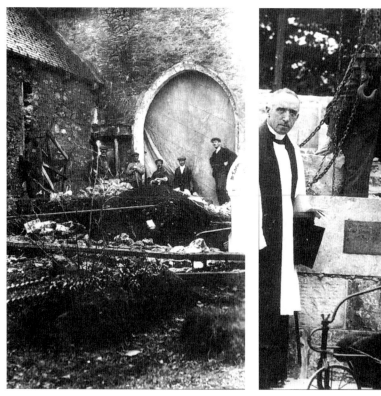
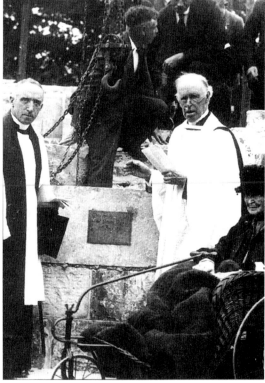

Left, father and sons at work on the building of the Lee Chapel, St Andrews, 1921 and (right) in their Sunday best for the laying of the foundation stone at St Peter's in 1929.

Britton's Yard was just under the Brickyard Bridge (known to the bus conductors as 'Marble Arch'). Here, in 1972, it has become Elmgrove Sawmills, run by H.J. Hawkins. Behind the yard, new houses occupy the brickyard site.

Painter & decorator, pre-1914. All this building created a demand for house-painting and Stewart Cram ran his business from his house on Mill Hill just below the present bank.

Dinas Powys Water Mill, *c.* 1900. The mill-leat carried water into a header pond behind the castellated building and so over the mill-wheel in the lean-to. Thence it flowed into the Mill Brook in the depression between the farmyard and the trees. The Mill House stands top right. There has been a mill on this site since 1426 and full accounts survive in the manorial records of the building of the first mill.

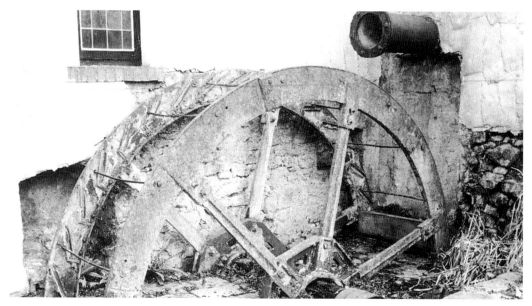

The mill-wheel in 1971. When the Mill was converted to a private house, the lean-to was removed to reveal the overshot wheel and the pipe through which the water gushed from the header pond. The woodwork slats of the wheel deteriorated very rapidly in the open air.

Some labourers were paid for their services, others did 'boon work', i.e. feudal dues owed to the Lord of the Manor in return for their strips of land in the communal fields. The millstone was imported through Aberthaw, but the wood was local, from Castlewood close by. Today the millstone is in the playground of St Andrews Church-in-Wales School.

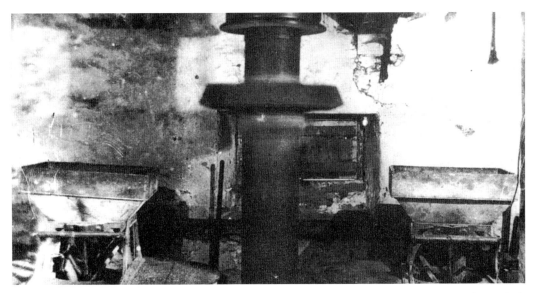

Inside the Mill, 1920s. The main drive shaft and belt are in the centre, and, on the left, the lever which privileged boys were allowed to operate to open the sluice, release the flow of water and start the wheel turning. In 1910-11 Joe Foster restarted the mechanism which had fallen into disuse and generated electricity to light the house and farm from a railway-coach dynamo giving a 22 volt dc supply.

DINAS POWIS, NR. CARDIFF,

Dec. 19*34*

M*r.* *Harvey Griffith* *The Weston.*
Dr. to

JOHN G. RANDELL,

BUILDING CONTRACTOR.

John Randell was another local builder with a sawmill and yard on Broth Lane.

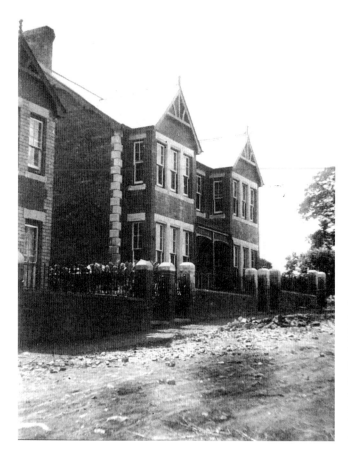

These are some of the houses John Randell built on Highwalls Road (Avenue). He was the father of Billy, Percy and Ted, already mentioned, and of Gwen Randell, who kept a draper's shop opposite The Star. Family interests in local business could be many and varied.

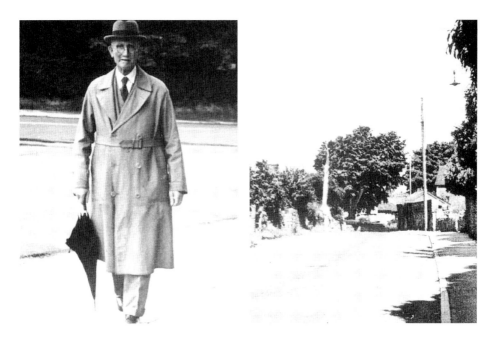

William Morgan was the blacksmith. He lived on Britway Road in the house just glimpsed to the right of the picture and in front of it stands the stone building that was the last smithy in the village.

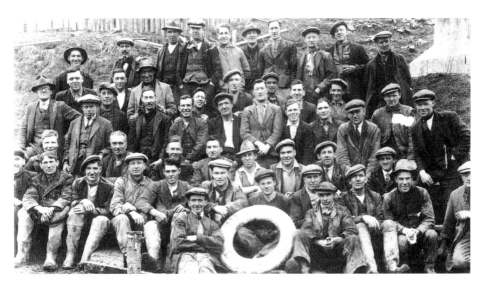

Gangers, 1933. The industrial depression and strikes of the 1920s caused hardship even in a village apparently so far removed from coal mines and heavy industry. Men who had built their fortune on the coal export trade suffered badly, and many families left the village in these years. There was also widespread unemployment among the labouring class, which included many ex-servicemen. As a result, building projects outside the village attracted men from Dinas Powys and Michaelston. The Norwest Road Gang built Leckwith Bridge in 1933, and this group includes 'Ginger' Orpin, Glanmor Courts, Charlie Nation, Leach, Bert Nation, Shep Hill, Dick Williams (with the white mark), Jim Orpin and Fred Hartland.

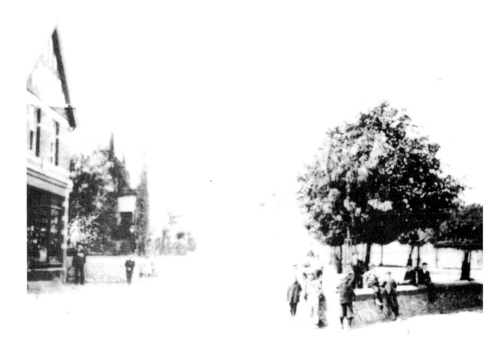

The post office, 1900. Frank John kept the post office in this shop built alongside the Twyn at the beginning of the century. Note the interest taken in the unusual sight of a photographer (Percy Randell). The schoolmaster and his family are in their garden and the usual group of village lads lolling on the Twyn.

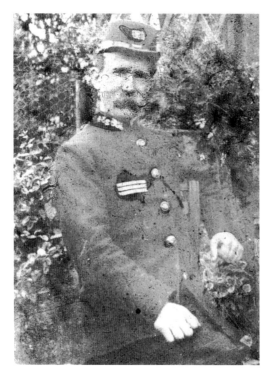

Mr Hoosen, the village postman, poses for a portrait in his uniform with its smart gendarme-type cap, early 1900s. He can be seen outside Ebenezer (p. 25a) and on the Square (p. 8). He dealt with the letters, but when Frank John received a telegram for delivery, he would call one of the boys who waited hopefully outside the post office. They were paid a halfpenny to deliver a telegram or a whole penny if the address was in St Andrews.

FRANCIS JOHN.
Stationer,
China, Earthenware & Fancy Dealer,
POST OFFICE,
DINAS POWIS.

LARGE ASSORTMENT OF PICTURE POST CARDS.

Stephens' Inks

Frank John commissioned his own set of colour views from Germany, which led the way in photo-litho techniques before the First World War.

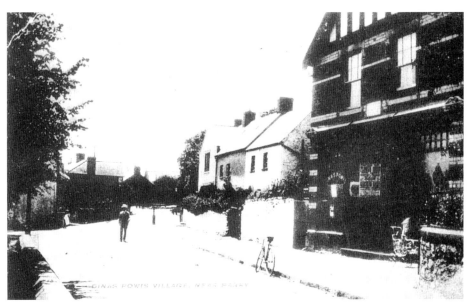

This is one of Frank John's postcards, postmarked 1906. There is an elaborate perambulator outside the door of the post office and a bicycle at the kerb. Beyond the post office is the wall of a thatched cottage purchased by the overseers as a parish bakehouse, and beyond that The Old Court and The Star Hotel.

The first doctor, *c.* 1910. Dr T.F. Roach (or Roche) lived at 'Briarbank' on the edge of the Common, with a surgery behind the house. He was an unorthodox practitioner who believed in overcharging the rich in order to pay for the treatment of the poor. 'He's alive, he can pay!' he said of a wealthy patient who received frequent visits from the doctor on his death-bed. But he would treat the poorer villagers without payment and was prepared to tackle any ailment, including tooth-drawing without an anesthetic. When visiting sick children he took gifts and crayons and, on one occasion, a white mouse! After he moved to London to work in the slums, the magazine, *John Bull*, gave him the title 'Friend of the Poor'.

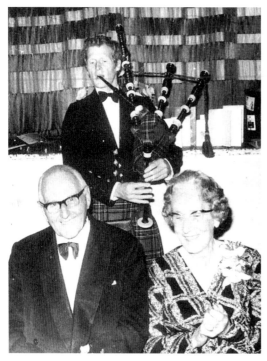

Dr and Mrs Beveridge celebrate their Golden Wedding anniversary, 6 September 1979. Dr Alexander Beveridge, who practised here from 1924 to 1961, was the friend of the whole village, and involved himself in many concerns, particularly the tennis club (see p. 127a). He never forgot his Scottish origins (recalled here by the piper) nor lost his Scottish accent.

Five

Transport

Carts and carriages, horse-brakes, steam-engines, cars, charabancs, buses – combinations of these vehicles have passed through our streets, increasing in number as the twentieth century progressed. In the mid-nineteenth century contact with the outside world was maintained by the weekly carrier's cart which started from The Angel in Cardiff and travelled via Leckwith and Penyturnpike through the village and Westra to Cadoxton. On its return journey, a 'cock-horse' might be required to help pull it up Penyturnpike and passengers were required to alight and walk up the hill. The main Cardiff to Barry Road was built in the late 1880s, following the course of the new railway through Eastbrook. A new road branched off at The Merry Harrier and gave a convenient route to Penarth. Gradually horse-drawn transport decreased, though the smart turn-out of Mr Matthews of the Mill Farm was a familiar sight in the village until after the Second World War. Horses will never entirely desert our streets, though now their use is only for recreation. Alongside all these changes moved the bicycle, growing lighter in weight and more manoeuverable. Bicycles appear so often in these photographs that they have not always been commented upon when other features are mentioned, but for most adults they filled the gap (as they do for youngsters today) between walking and acquiring that once most expensive, but increasingly affordable, item – a car.

Day-trippers had long been a familiar sight passing through Dinas Powys, leaning out of the windows of crowded trains on their way to Barry Island. In the years after the Second World War huge groups of cyclists used to pass through on their way to the same destination. Those who lived on Cardiff Road will remember quiet Sunday mornings when voices heard in the distance grew louder and louder until thirty or forty cyclists swished past in close formation, their talk and laughter dying away along the Barry Road. But there is no doubt that the biggest tyrant – and amenity – has been the internal combustion engine with the petrol pumps and garages needed to maintain it. And in Dinas Powys all this began around 1905.

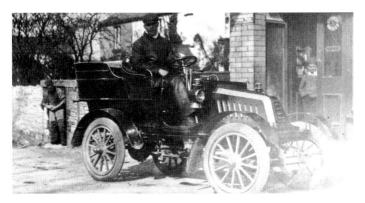

The first car in Dinas Powys, *c.* 1905. This model – a De Dion Bouton – was known as 'the doctors' car' as they were usually the first to see its possibilities for speeding up their round of visiting. It is photographed outside Howell's Steam Bakery in Station Road. Mog Miles has emerged from the back gate of Old Mount Farmhouse to have a close look and a little boy is lounging in the doorway. Above his head is another concession to the modern world – 'You may telephone from here'.

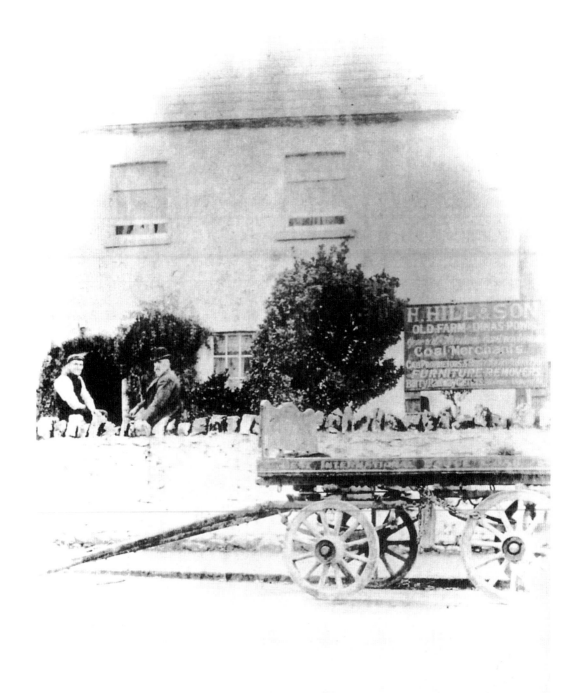

Hills of Old Farm. Walter Hill and his father Henry are seated in the garden of Old Court (then known as Old Farm). The extent of their haulage business is advertised above their wagon – 'H. Hill & Son/ Old Farm, Dinas Powis/General Hauliers & Contractors/Coal Merchants/Cab Proprietors & Brake Hire/Furniture Removers/Barry Railway Contractors/Best House Coal.' The firm later became Hill's Transport (Cardiff) Ltd (see p. 119a).

Delivering the milk, 1910 (above) and
1933 (below). The milk-cart with its old-
fashioned churn is on Mill Hill. The gate
to Hill's cottage is on the right, and the
dark shade of the trees on the left marks
where St Peter's will be built twenty years
later. The milkman has gone off with his
measuring cans to ladle a pint or half-
pint into the jugs which the housewives
have ready for him.

Twenty-three years later the milk was
still transported in a churn – milk
bottles had not yet appeared on the
scene. But the milkman (possibly Gwyn
Roberts) has adopted mechanised
transport. He has parked opposite The
Star with Old Court (and the ubiquitous
bicycle) in the background.

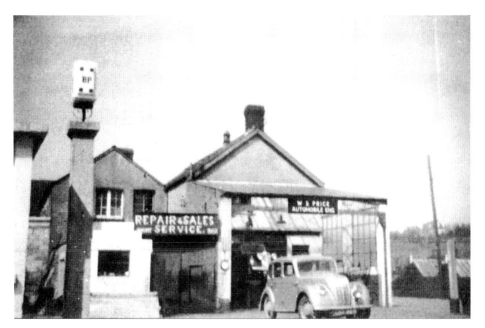

William Stanley Price ran his garage on the site of the old bakery from 1935 to 1951. On the right of the photograph are Barrett's greenhouses in Greenfield Avenue.

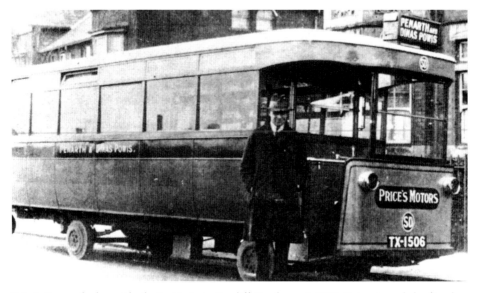

Price's Bus parked outside the Institute in Cardiff Road, 1926. W.H. Price started the first bus service to Penarth, running from the Institute in Dinas Powys to the old post office, on the corner of Bradenham Place, Penarth. He named his Ford T-type saloons 'The Dinas' and 'The Powis'. He also had a small charabanc named 'St Andrews'. This was the last of his buses, a Shelvoke & Drewry Freighter chassis with 20-seat body. He purchased it in July 1926 for the Dinas Powys-Penarth Service, but sold it to Messrs Thomas White & Co. of Barry in 1927. The driver is Joe Foster of Greenfield Avenue.

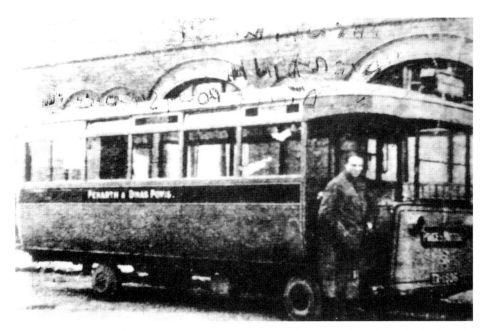

Price's Motors, Penarth Bus, 1920s. Joe Foster is pictured again at the side of the Institute in Elmgrove Road. This, another of Price's buses, is an SD Freighter – a model more often used as a corporation dustcart than a bus! It was known as a Tramocar from the tram-type controls.

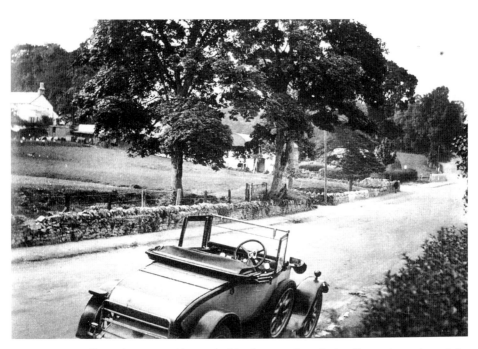

Open car on Mill Road. Dr Beveridge took this photograph undoubtedly to give a view of the Mill Farm and Penyturnpike. Its chief interest today is the car with the fold-back roof and the dicky seat. Parked outside 'Glenview', it was probably the doctor's own car.

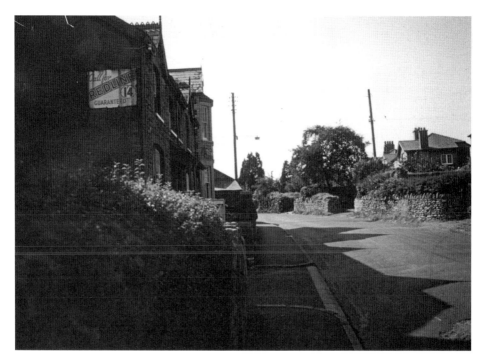

Llewellyn Price was affectionately known as 'Squeaker'. His garage was behind his house in Britway Road, and from here he ran a taxi service. A few years ago all that remained was this sign with its incredibly low price!

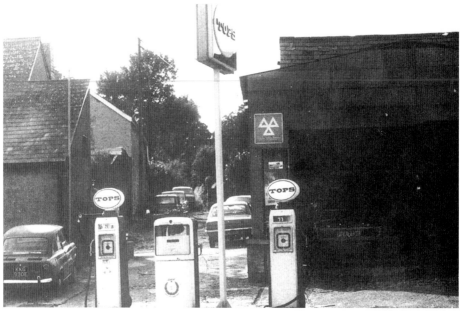

Petrol pumps outside Old Farm Garage, 1950s. Designs have changed even in something as utilitarian as a petrol pump as can be seen at Watts' Garage in the centre of the village.

Dinas Powys railway station, *c.* 1900. The first train had run along these lines in December 1888, the engine bedecked with flags and the carriages laden with dignitaries. Among them was General Lee, who alighted from the train to make a speech while Miss Grace Alexander hung a floral wreath on the engine. The schoolchildren were given their first train ride to Barry Island on Friday, 18 July 1889, the day after the opening of the first dock at Barry. Gardens were a feature of the station platforms as long as there were staff to maintain them.

Dinas Powys station viewed from the old station bridge, *c.* 1910. The siding for shunting coal trucks is seen to the right. Here at the bridge a cutting had been made through the limestone, just visible on the left. The sharp turn on the road was eased out on the new bridge just as traffic increased before 1939.

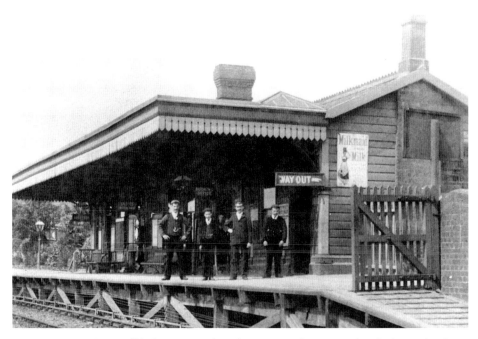

Dinas Powys station staff before 1913 when the Barry Railway was absorbed into the Great Western Railway. From left to right: Station-master Roblin, porters Billo Ashton and P. Pugsley, and Ted the signalman. Behind them on the platform are chocolate and weighing-machines and the gas-lamp lighting the station garden.

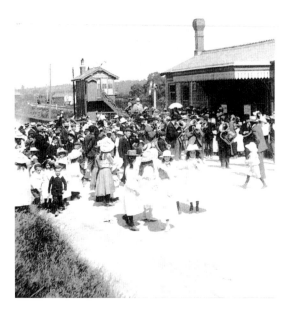

Outside the station, 1902 (see also p. 95). There was a certain 'Swiss chalet' charm about the stations and signal-boxes on the Barry Railway. The signalman was a general friend, quite prepared to hold up the train if he could see passengers running to the station! Here he has decorated the signal-box with flags to welcome home soldiers from the Boer War. The signal-box was demolished in 1957 and by 1970 the station, too, was ready for replacement by a concrete box. Gone were the days of the bright coal fire in the waiting room and the familiar 'GWR' smell.

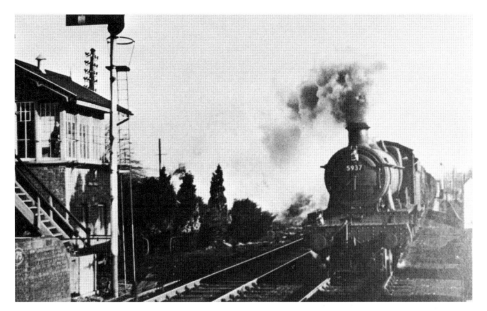

Heading west under steam. The signal-box has survived the transfer from the Barry Railway to Great Western and then to British Railways. It is Sunday, 30 January 1955 and the freight train, pulled by the ex-GWR 'Hall' class engine No. 5937 has been diverted from the main line.

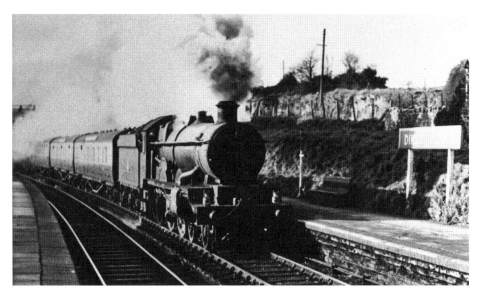

The Paddington train, 1955. It is the same morning, Sunday, 30 January, and due to engineering work on the main line, the South Wales-Paddington train has been diverted through Dinas Powys. It is No. 5082 of the 'Castle' class built by the GWR and named after aircraft that had distinguished themselves in the Second World War. This is *Swordfish*. The vagaries of the spelling of the village name were reflected for many years on the station, where the platform proclaimed 'Dinas Powis' and the signal-box 'Dynas Powis'. Today we have returned to the fourteenth century version 'Dinas Powys' which is becoming generally accepted.

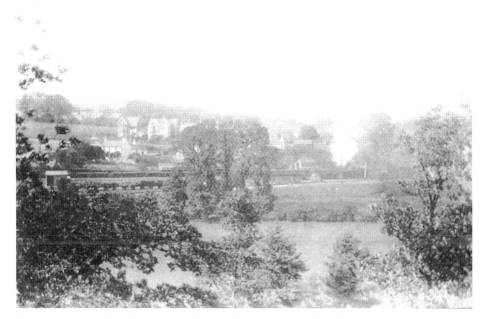

The station and siding. The once familiar puff of steam on the line. In the foreground the siding and a small branch line to the brickworks. In the background the Malthouse and the buildings on the edge of the Common where Dr Roche had his house and surgery.

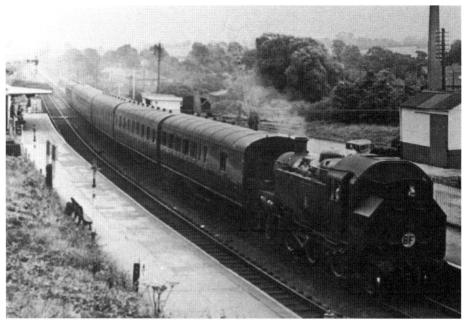

Barry Island train, 1955. For most children of the author's generation the station had its own special excitement as the prelude to a day on the sands at Barry Island. It is 1 September 1955, and a British Railway standard tank engine No. 82036 is picking up passengers on the down-platform.

Six

War and Remembrance

Rumours of conflict had reached Dinas Powys long before the first bombing of 1940 brought home the reality of total war. On 4 June 1871 General Lee recorded in his diary that 'there was buried at St Andrews an old soldier who had fought in the Peninsular Wars with Wellington, one John Williams, Coldstream Guards. He lost a leg in the siege of Bayonne, April 1814. He was maternal uncle to J. Morgan of Westra Farm where he died'. A plaque in the porch of the parish church repeats these battle honours 'as a tribute from one soldier to another'. Could the General have been the donor? Thomas Bates Rous who 'served in Spain under Sir John Moore in the Grenadier Guards' is commemorated at Michaelston. In the ensuing years the guardians made small payments to discharged soldiers and sailors and moved them on to the next parish, but by the time of the Boer Wars at the end of the century communications had improved and news travelled faster. Sons of the Rous and Isaac families received a rapturous welcome home at the end of the war (see below) with parties for schoolchildren and general rejoicing. Miss Jayne, who ended her days at 'Claremont' on Cardiff Road, was another veteran of the South African War during which she was taken prisoner by the Boers. She became a member of Queen Alexandra's Imperial Military Nursing Service, and during the First World War was awarded the Royal Red Cross. She was photographed in old age in the group of ladies preparing for war in 1939 (p. 104a).

These were individuals who distinguished themselves. In 1918, the executive of Dinas Powys and District Red Cross and Social Services Association drew up a list of 316 names of those men and women who had served in the armed forces during the war. The Second World War brought an even greater participation both in the fighting forces and in the ranks of Civil Defence. Air Raid Precautions (ARP) were on the minds of all householders as they erected their shelters and taped their windows, but the Rector had the most unusual task. He wrote in the Parish Magazine for October 1940: 'I have received a letter from the Church authorities asking me to take steps to make the graveyard round St Andrew's Churchyard less conspicuous from the air. White marble tombstones make churchyards and other burial grounds notable landmarks by day and on moonlit nights. Shrouding them with common evergreens, such as holly, ivy or laurel is suggested to reduce the danger'. Now the war had indeed come to the village, which soon bore the scars of 218 bombs, though there were no fatalities.

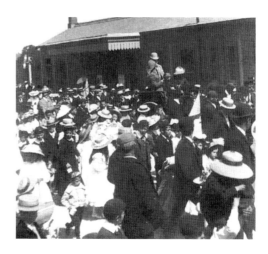

Return from the Boer War, 1902. Schoolchildren and village band have turned out to welcome home Harry and Noel Isaac. Enthusiastic villagers drew their trap home to Elmgrove House. (See also p. 92b)

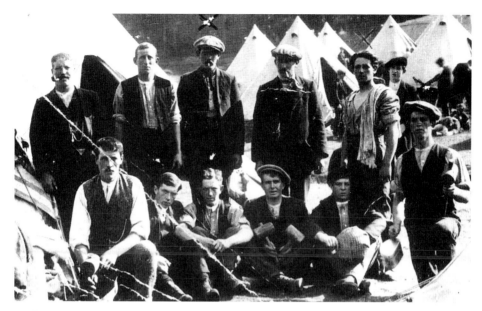

Kitchener's Army, Bisley Camp, Aldershot, September 1914. At the outbreak of war in 1914 there was intense enthusiasm to join up and have the war 'over by Christmas'. These men from Michaelston and Dinas Powys joined the Devonshire Regiment in August and are pictured here at Aldershot a month later still in 'civvies' but settling down under canvas. From left to right, back row: Dick Kitch, Charlie Collins, Phil Hopkins, Owen Pugsley, Arthur Chappell. Front row: Bill French, Ivor Hopkins, Bill Hopkins, Tommy Stock, Charlie Coombes, Fred Hopkins.

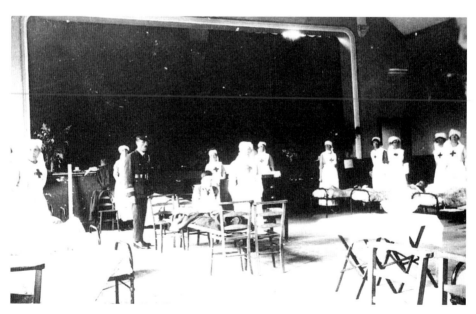

At home – a Red Cross 'emergency', 1915. Before the opening of the hospital, the Red Cross had used the Parish Hall to practise the reception of wounded soldiers, and they involved the Girl Guides and Boy Scouts as orderlies and 'patients'.

Idris Davies of the King's Own Cavalry,
photographed in France.

Bessy Hussey from Michaelston on her
way to France as a member of Queen
Alexandra's Imperial Military Nursing
Service, of which Queen Mary was
then President. Bessie and Idris Davies
were married after the war.

Dick Williams on 'Blacklead' on Salisbury Plain, 1914. Dick Williams joined the Army on impulse a month before his sixteenth birthday and was accepted as 18 by the recruiting sergeant and by the army doctor, both anxious for recruits. He was drafted into the Royal Artillery and by February 1915 his skill with horses had earned him the position of lead driver on the six-horse team of an 18-pounder.

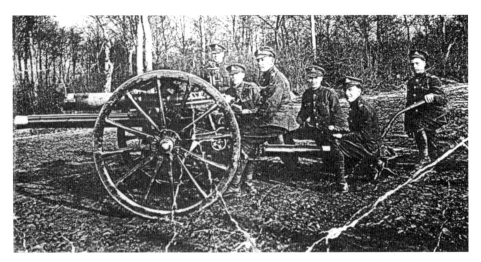

Dick Williams with the guns in France, 1915. Promoted to bombardier, Dick sailed for France in July, 1915, and fought through the battles of Loos, Ypres and the Somme. His chief memories were of the sky aglow with gunfire at Ypres, of horse-teams lost in the mud and shell holes at Ginchy, and his devotion to his horses whose instincts saved his life more than once. He was grateful, too, for the parcels of socks, hankies, shirts and balaclava helmets sent to the troops by the Dinas Powys Red Cross.

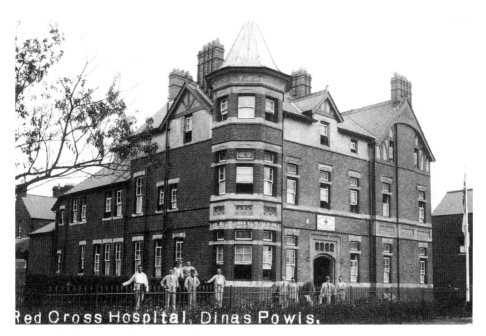

Red Cross Hospital, Dinas Powis.

Wounded soldiers convalescing outside the Red Cross hospital at Dinas Powys Institute. The hospital opened on 15 June 1916. It was the gift of T.P. Thomas and his wife was in charge. Wounded soldiers were received in the hospital and in the house at the corner of Elmgrove and Cardiff Roads. Their blue uniforms soon became a familiar sight.

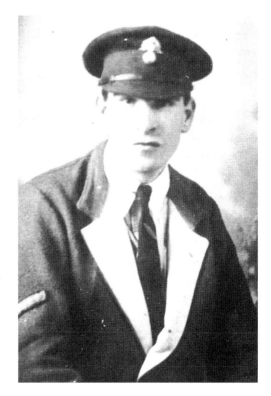

Lance Corporal Cecil Buckingham in 1918. Probably the most badly-wounded soldier to enter the hospital, when he was able to move about on crutches he took charge of the Scouts who were acting as orderlies in the hospital. Once fully recovered, he returned to England and was ordained priest in 1923. During the Second World War he served as chaplain to the forces in an anti-aircraft battery.

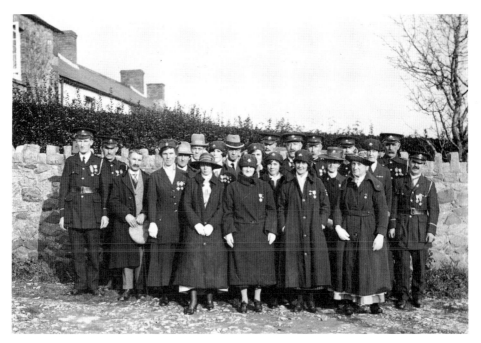

Dinas Powys Red Cross detachment during the First World War. The group photographed on the Square includes Will Spear, Gwyn Roberts Snr., Dick James, Johnny Collins, Mrs Percy Jones, Godfrey Williams, Mabel Chapel, Nellie Thomas, May and Muriel John, Miss Lee, Jim Mason, and Mr and Mrs Donaldson.

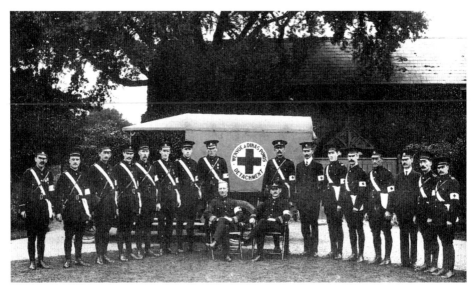

Red Cross ambulance, First World War. The Wenvoe and Dinas Powys detachments of the Red Cross joined to run this ambulance, chiefly used for transporting wounded soldiers from the train in Cardiff to the Red Cross Hospital. On one occasion Howell Jones, the schoolmaster, had to record this in his logbook as the reason for his absence from school. He is in this group, as are A. Pirie, R. Donaldson and J. Collins. Behind them is the coach-house of 'The Mount'.

IN GRATEFUL MEMORY
OF
ARTHUR JOHN BLACKMORE
CHARLES COLLINS
NOWELL EDWIN COOPER
DAVID WILLIAM EVANS
WILLIAM HENRY GEORGE
ALEXANDER HODGSON
HENRY HERBERT HOWELLS
ERNEST JOHNSON
RICHARD KITCH
DAVID LEWIS
FRANK PEACHEY LEWIS
JOHN PEACHEY LEWIS
ALBERT MILLER
LESLIE CAMBRIDGE NEWMAN
WILLIAM JOSEPH OLIVER
FRED. RICHARD PRICE
GEORGE HENRY PRICE
WM. STEBBLES PROCTER
MARK PULSFORD
CHAS. CLIFFORD ROBERTS
CHAS. RICKINSON ROBERTS
THOMAS SMITH
ARCHIBALD THOMAS SPEAR
GEO. MERVYN STOTHERT
HENRY GEORGE TROTT
EDWARD VENN
HENRY WHITE
GEO. HENRY WRIGHT

OF THIS PARISH WHO LAID
DOWN THEIR LIVES IN THE
GREAT WAR 1914-1919.

JESU MERCY

The War Memorial at St Andrews. The memorial tablet in white marble records the names of the twenty-eight men who made the supreme sacrifice in the 1914-18 War. It was unveiled in November 1920 at a parade of Red Cross members and ex-servicemen.

The lych-gate, Michaelston, commemorates William and Arthur Hopkins and William French, killed in the First World War. The lych-gate was dedicated by Bishop Lloyd Crossley on 28 June 1926.

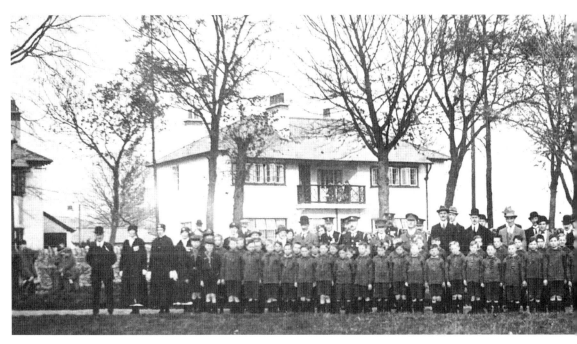

The first Armistice Day Parade, 11 November 1923. Since 1923 the annual Remembrance Day Parade organised by the British Legion has kept alive the memory of the courage and self-sacrifice of those war years. Drawn up on the Common, from left to right, are: detachments of the Red Cross, Scouts,

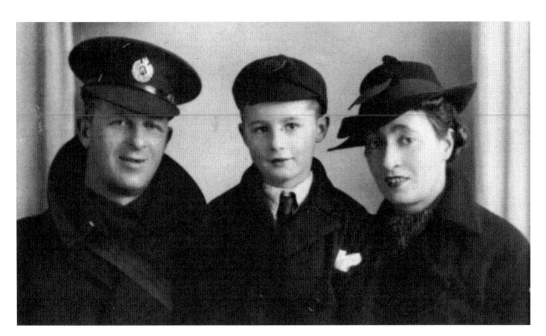

During the First and Second World Wars there were many poignant photographs like this where, in 1941, George Thomas posed with his wife Lettie and son David on embarkation leave before departing for service overseas and an uncertain future.

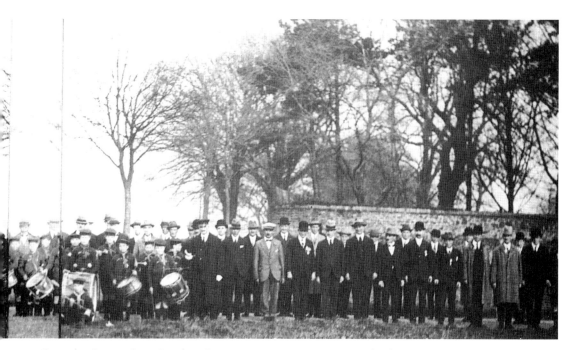

Brynydon Boys, a Scout Band, and ex-servicemen. Mervyn, Dora and Sylvia Lewis are watching from the balcony of Twyncyn House.

The War Memorial on the Twyn, Dinas Powys, was not dedicated until 1935. There had been controversy as to the form the village memorial should take – many wanted the more practical option of a hospital. When an appeal for funds was issued, the design was to be in the form of a cross. The final choice of a plain cenotaph in local stone blended well within the Twyn and became the focal point of the village square. Within a decade there were more names to be added.

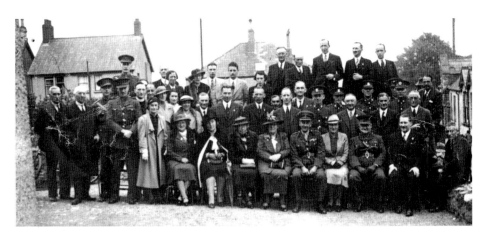

Preparations for Civil Defence, 1939. These photographs are something of a mystery. During the Second World War some secrets were so 'hush-hush' that they died with the people involved. Both these pictures were taken outside the Parish Hall in 1939. The first appears to be a group of prominent people in the community with representatives from the Army and Police Force. Only these have been identified – back row (centre) Betty Cooper, J.W. Davies 'The Rates' (Parish Clerk) and Vernon Hawkins. Middle row: Revd D.V.S. Asher (Curate), Mrs 'Gas' Jones, Gough Jenkins, Philip Harper, Ralph Seel, Mr Byrne, Tom Baker, Howell Jones, Major Layman, Selwyn Martin. Front row: Mrs and Miss Byrne (seated), Mrs Davies 'The Rates', Mrs Rees, Miss Jayne, Mrs E.M. Brain.

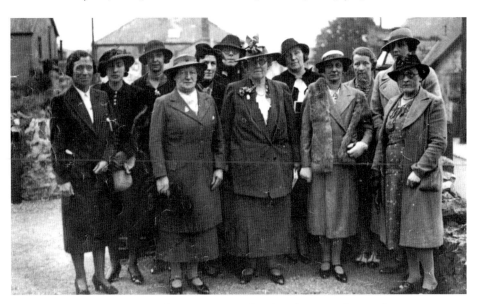

This second group is obviously a ladies committee, but though it was taken on the same occasion, they were not all in the first group. Perhaps the ladies were to be part of that select group who met weekly to make 'skrim' – camouflage netting. Most would be involved in Civil Defence in one way or another, and Mrs Brain, who is wearing the badge of the Women's Voluntary Service, was the leader or convenor, taking the centre place in each photograph, From left to right, front row: Mrs Davies, Mrs Brain, Mrs 'Gas' Jones, Miss Dot Williams. Behind them: Mrs M.V. Hick, Mrs Seel, Mrs Rees. Back row: Mrs Harvey. Though in the 1930s Dinas Powys people tended to think of themselves as English rather than Welsh, the Welsh custom of nicknames is firmly implanted in the memories of those who recall 'Davies The Rates' and 'Gas' Jones.

'Dad's Army' – Home Guard, 1940. Henry George Tilney lived at 'Wyecliffe', Cardiff Road, and was headmaster of an elementary school at Pentwynmawr in Monmouthshire. He had served in the South Wales Borderers in the First World War, and, too old for active service in the second, he joined the Local Defence Volunteers, which became the Home Guard. He was promoted to corporal. Their duties consisted mostly of manning various posts around the village, including the bowls club and the Old Mill.

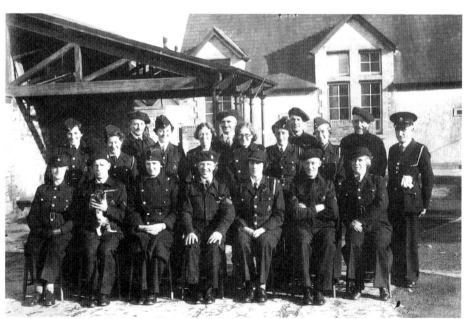

Manning the ambulance post in the 1940s. An ambulance post was set up in the National School, and the group of volunteers is photographed in the playground in front of the old shelters. The group includes Miss Ebbet, Josie James, Mrs Jones, and Jack Smith.

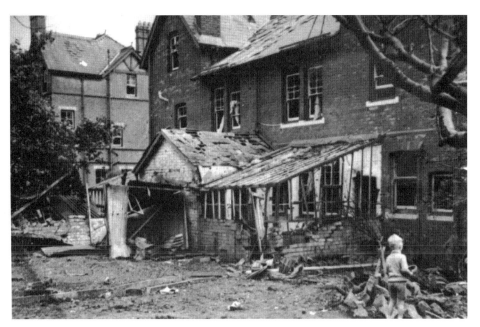

The bombing, 1940. Above: 'Grouville', 41 Cardiff Road, 1940. The bomb crater is in the foreground – this was an anti-personnel bomb, small by later standards, but large enough to destroy the outbuildings and the corner of the house, and shatter the windows as far as the Institute. Ian Wilkie plays amid the debris. Locals swore that the first bombing raid on Dinas Powys was provoked by the stoker who was in the habit of opening the fire-box of his engine and stoking the boiler as the train passed through Dinas Powys before entering Cogan tunnel. When this happened on the night of 29 June 1940, a German bomber was overhead and attempted to bomb the railway line so conveniently marked out for him. The bombs straddled the line from Southra Farm to The Murch but did not actually hit either the railway or the train. The closest the bombs came was between Nos 39 and 41 Cardiff Road, opposite the line. Below: 'Grasmere', 39 Cardiff Road, 1940, with shattered windows, conservatory and outhouse, and the leaves all blown off the tree.

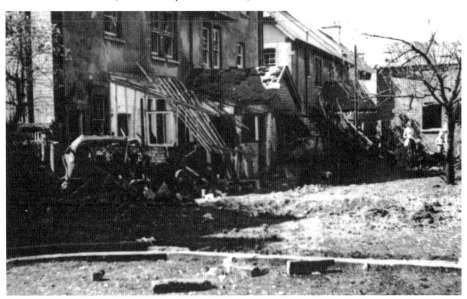

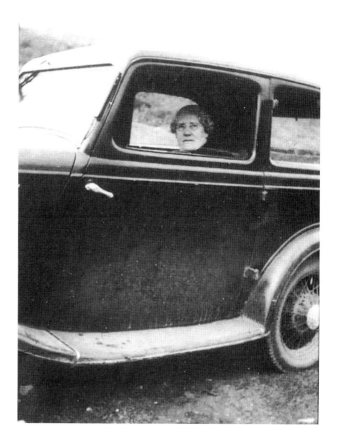

Before and after 29 June 1940. The car in these pictures belonged to Mr and Mrs Jack Morgan who lived in 39 Cardiff Road. Mrs Morgan, seen (right) before the bombing, was the first trained midwife in the village.

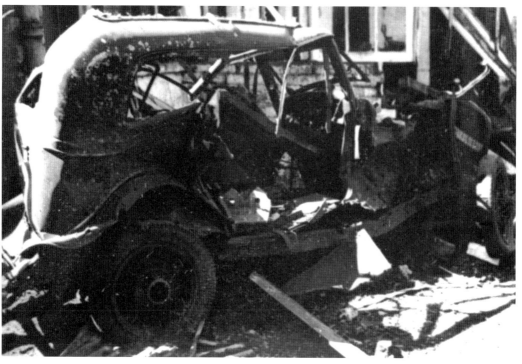

A bomb fell close to the Westra Fawr Farmhouse on 12 August 1940. Blast from a bomb had a strange effect. On the dresser in the farmhouse kitchen was a large china bowl of new-laid eggs. The bowl was cracked across and came apart in the hand, but the eggs were unbroken.

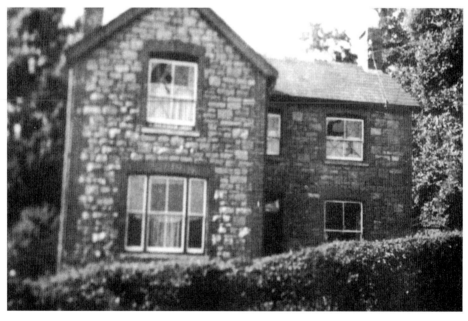

'Rosebank' (now 'Cilrhosyn') is across the road from Westra Fawr Farm. Advice given to householders was to tape their windows. The picture illustrates how the sticky tape prevented flying glass even though the windows were shattered following the blast.

The memorial at St Andrews to the dead of the Second World War took the form of a stained-glass window in the north aisle. St Michael is depicted above the RAF crest, St George was chosen to commemorate the Army, and St Nicholas, patron saint of sailors, for the Royal and Merchant Navies.

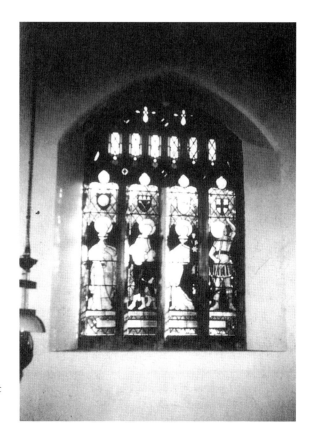

The son of Sir Herbert Merrett of Cwrt-yr-Ala was an RAF pilot killed in the Battle of Britain. He is buried just outside the west end of St Michael's Church. In his memory Sir Herbert gave this west window by Sir Ninian Comper, representing the warrior saints.

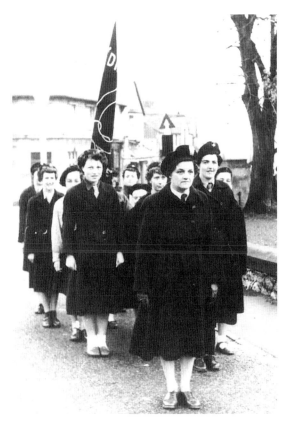

Remembrance Day Parade,
c. 1952. After the Second World
War 'Armistice Day' was renamed
'Remembrance Sunday' and
celebrated not necessarily on
11 November, but on the nearest
Sunday. The youth organisations
were invited to join the annual
parade to St Andrew's organised
by the British Legion. Here the 1st
Dinas Powys Guides, led by the
District Commissioner, Miss E.S.
Hardman and Captain C. Tilney are
drawn up by the War Memorial.

Mametz, 1916-1987. As the
years passed, ex-servicemen still
remembered the horrific loss of life
in the battles of the First World War.
In 1987 Dick Williams returned to
Mametz Wood for the dedication
of the dragon memorial and visited
the grave of a fallen comrade
from Dinas Powys, Pte. George
Wright, who died from his wounds
at Mametz on 10 July 1916. He
has a memorial in the porch of St
Andrew's church.

Lionel Beveridge and Dick Williams
preparatory to the wreath-laying
ceremony, at the War Memorial in
the Square, 1986.

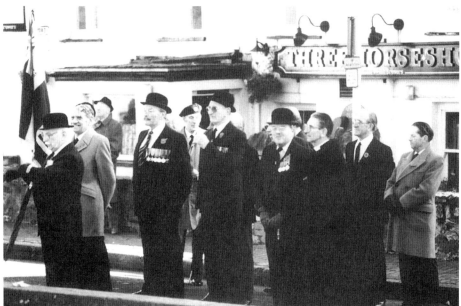

The local branch of the British Legion gathers for the march (downhill now to St Peter's) and
the annual Remembrance Service, 1986. In the group, from left to right: Colonel Woods, Huw
Naish, David Southall, Harry Welchman, Charles Davis, Dennis Hampton-Jeffrey, Chancellor
James Keane, Stan Glover, David Roberts.

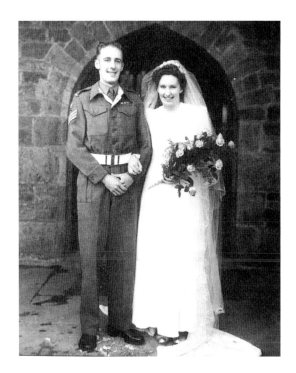

Victory wedding, Sergeant Harry Welchman and Miss Mary Shepherd, 19 June 1946. They were the first couple to have their banns called at St Peter's. Though it had been licensed for marriages, most wartime weddings were by special licence during the brief leave from the forces. Harry and Mary were married on 19 June 1946 and celebrated their Golden Wedding anniversary at the same church fifty years later to the day.

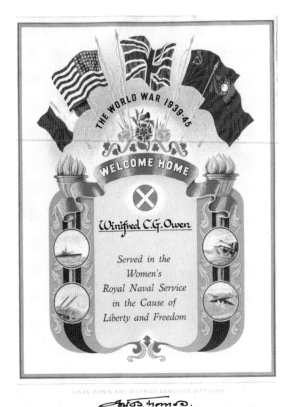

Welcome home, 1945. Certificate signed by Sir Ivor Thomas, Chairman of the Dinas Powys and District Services Gift Fund.

Seven

Sports and Pastimes

The late nineteenth and early twentieth centuries saw a proliferation of clubs and societies as villagers organised their own amusements close to home. Some of the activities had an emphasis on improvement as well as enjoyment. Jane Greatrex won a prize for handwriting at the Dinas Powys Cottagers' Horticultural Society Show in 1904, and Percy Randell mounted his prints and wrote his historical essays for the Dinas Powys Eisteddfod. Maria Claudy progressed through local competitions to become Champion Dairymaid for Wales in 1892.

Under the patronage of General Lee and Miss Marion Lee the Boy Scouts and Girl Guides flourished in the village, with Wolf Cubs and Brownies to follow. Each church and chapel had its own Sunday school with an annual treat. On Whit Monday the Cardiff Sunday schools came to the Common. They boiled the water for their tea in portable stoves with tall flues and served it in their own marquee. Better still, for the village children, they brought slides and swings and hoop-la stalls and all-comers could join in for a penny or halfpenny a go. After the Second World War came the era of youth clubs, and the Methodist Church erected its own Youth House opposite the chapel in Station Road.

Dramatic and choral societies have flourished and faded, but for the adults the longest-lasting have been the sports clubs. Both the cricket and rugby clubs have celebrated their centenaries and are still going strong. The bowls and tennis clubs reached a hundred years in 2002, and the golf club will celebrate its centenary in 2014. Players and spectators alike can enjoy their sports in country surroundings, and the favourite walks of earlier generations have not been forgotten.

Cup winner, *c.* 1920. William Horne was head gardener at 'The Mount' from 1904 until 1916. He enlisted in the Royal Flying Corps a few months before his fortieth birthday in 1916 and served in France. He returned to 'The Mount' but emigrated to Canada shortly after the General's death in 1920. He won these trophies for his skill as a gardener. One is engraved 'Penarth Rose Society' and his grandson in Canada treasures the largest, from Barry Chrysanthemum Society, won by William Horne in 1908 and in subsequent years until he won it outright. This is now the only cup retained by the family. They believe that he sold all the other trophies to pay for his family's fares to Canada. His grandson would dearly like to recover them.

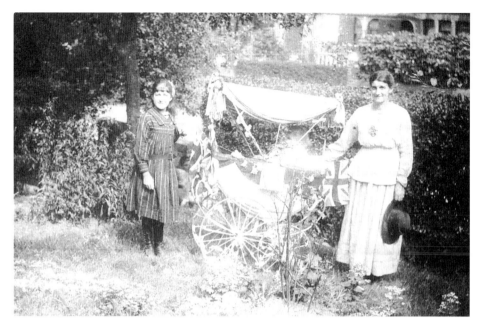

Bonny Baby Show, 1915. Mrs Margaret Hill and her daughters, Gertie and baby Frances. Lady Joseph Davies has just presented them with two prizes for the 'Bonniest Baby' and the 'Best Dressed Perambulator'.

'The Stepping Stones', 1932. There were plenty of places for country children to play, but a favourite was the stepping stones beside the Mill. The water was never very deep but crossing the stones became an adventure when the sluice-gates were open and the leat was flowing into the brook, not the mill-pond. Here John Byrne is attempting to sail a toy yacht. Others fished for minnows and bull-heads. This play-place, always unofficial, was lost to later generations when councillors made a verbal agreement with Herbert Thurston, who had converted the Mill into a private house, and the brook was fenced.

The Strawberry Field, 1930s. A favourite walk in summer and autumn was up the Twyncyn, past Witchwood and along the lane to the Strawberry Field. Here the strawberry season is over and Ethel Cox, Ellie Lewis, Flo Bevington and Violet Cox are gathering hazelnuts. The field was ploughed during the Second World War and the wild strawberries no longer grow there.

On the swings, 1950s. After the Second World War, councils began to consider the provision of playgrounds for children outside school. At Eastbrook and on the Common the Parish Council erected swings and roundabouts. Here the swings on the Common are being enjoyed after school by Angela Mason, Edward Jenkins and Carlton Hobbs. In the background is the brickyard pond, and the Murch and Sunnycroft are dotted with only a few houses where the estates cluster today.

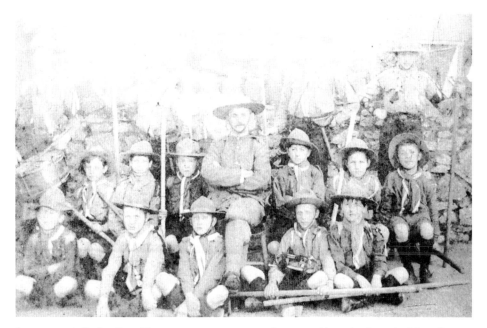

Scouts, 1908. Baden-Powell's scout movement was taken up with enthusiasm in Dinas Powys. This very early photograph shows the troop with its staves, flags and drum. They served as orderlies in the Red Cross Hospital during the 1914-18 War and often acted as 'runners'.

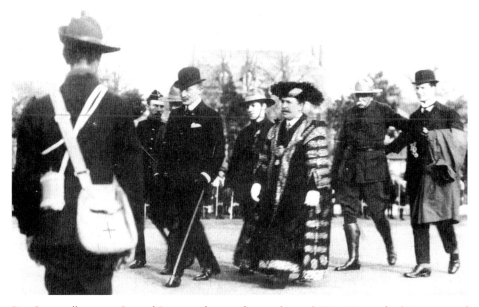

Boy Scout rally, 1909. General Lee soon became known beyond Dinas Powys for his support of the movement. He seems to have been a personal friend of B.P., who stayed at 'The Mount'. Here the Founder, then Sir Robert Baden-Powell, inspects a rally of Boy Scouts outside Cardiff City Hall. He is accompanied by the Lord Mayor, Alderman John Chappel, Sir Robert's aide-de-camp, and General Lee in Scout uniform.

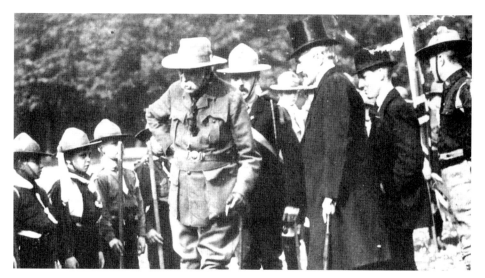

General Lee inspects the Boy Scouts, 1911. General Lee, looking remarkably like an elderly B.P., inspects an Empire Day Rally in Sophia Gardens, Cardiff, in 1911. He is accompanied by Lord Mayor, Alderman Sir Charles Hayward Bird. At the General's funeral his body was conveyed from 'The Mount' to St Andrews on a Scout trek-cart, and the whole way was lined with Boy Scouts, their heads bowed over their staves.

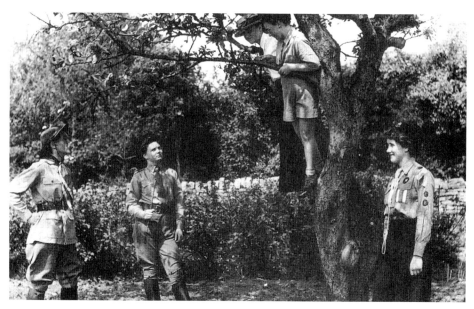

A Guide Play, 1957. Here the 1st Dinas Powis Guides act a scene in the life of the Founder. Patricia Sessions (left) makes a convincing Baden-Powell, and Kathleen Spiller the general who entertains him. Up in the tree, the governess (Angela Mason) is teaching the general's son (Marilyn Hewins) one of the principals of stalking – the need to look up as well as around you! Margaret Griffiths, in Guide uniform (right) was the narrator when this play came second in the Guide Eisteddfod for Wales at Broneirion, Llandinam, in 1957.

Scout & Guide folk-dancing team, 1957. The 1st Dinas Powis Scouts and Guides combined for the same eisteddfod, and like the drama group, won second place. From left to right: Sandra Moore, Linda Wilson, David Ashmore, Ann Roberts, Camelia Griffiths, Bruce Mason, Margaret James, Carol Evans and Peter Thompson.

Coronation parade, 1953. British Legion, Scout and Guide colour parties outside St Peter's for the village service to mark the coronation of Queen Elizabeth II in 1953. Herbert Scourfield and Jim Orpin are with the Legion colours and Shirley Roberts, Sandra Moore, Shirley Chappell, Shelagh Dunford and Lynne Reynolds with the Guides.

Off to camp. A new use for Hill's Transport as the Guides leave for camp at the Vishwell Farm. Among those in the picture are: Angela Mason, Edna Wilding, Christine and Carol Evans, Linda Wilson, Penny Lumley, Sandra Moore, and Guide Captain Chrystal Tilney.

Guide Jubilee, 1973. The 1st Dinas Powis Guides celebrated the Golden Jubilee of the registration of their company in 1923 (though the company certainly existed, unregistered, during the First World War). Here, in St Peter's Church Hall, Miss Daisy Green, the first Guide Captain in Dinas Powys, cuts the celebration cake. She is watched by guides in uniforms of different periods, by her former Lieutenant, Mrs Eva Rowlands (*née* Tinkell), and by the current Guider, Mrs Chambers.

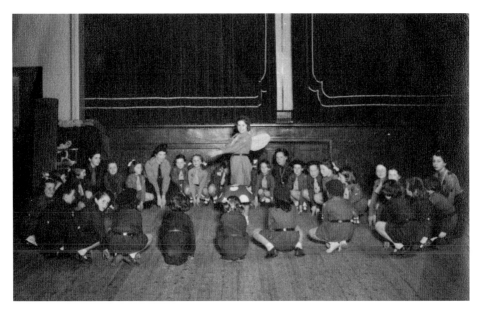

Brownies in the Parish Hall, 1950. During a Brownie Concert, Susan Foy of the 4th Dinas Powis Pack was ready to 'fly up' to Guides. The Pack Leaders are Shirley Roberts and Ruth Thomas. The other Brownies are congratulating Susan with a 'Grand Howl' – 'To-whit-tu-whit-tu-woo'!

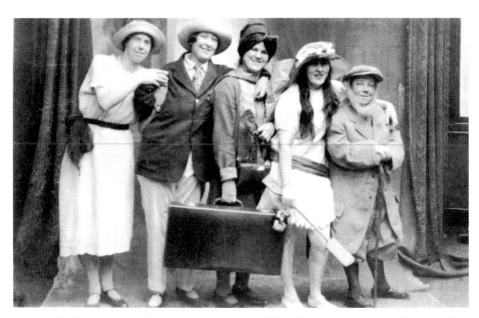

Girls' Club play, Parish Hall, *c*. 1922. A very successful Girls' Club was organised by Mrs Cox in the 1920s. These were the principals in one of their plays, among them Ada, Dot Williams and Maggie Goodfellow. Maggie was an Eastbrook 'character', sometimes with a sharp tongue (she was the terror of the conductors on the Penarth buses) but always ready to join in the fun. In 1937 she appeared on the Common at the Coronation Sports, dressed in a knitted red, white and blue tube-dress from neck to ankles, and riding a fairy cycle.

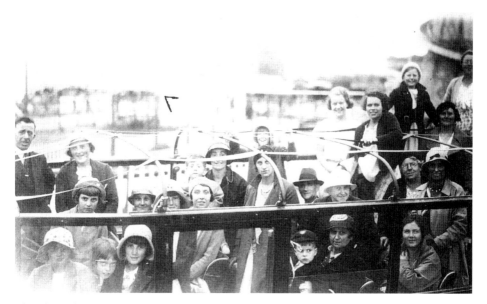

Church Sunday school arriving at Coney Beach, Porthcawl by open-topped charabanc. Seated, on the right: Miss Madge Pirie. Among the group are Mrs Pengelly, Jean Bennett, Josie Bowles, June Hartley, Ray Dunford and Sarah Dunford.

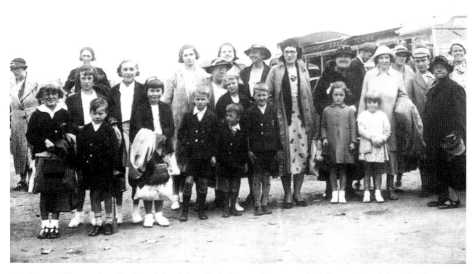

Outing to Coney Beach. An older Maggie is instantly recognisable on the right of this group, mainly from Eastbrook, on another trip to Porthcawl. Also in the group are: Sylvia Miles, Mary Ogden, Mrs Slimmins, Dick Balmont, Mrs Gadsby and Muriel.

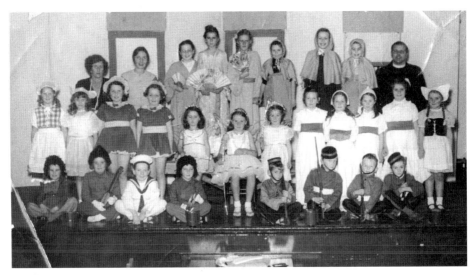

The Little Girls' Club, 1950. The Curate, Revd Hywel Davies, and Mrs Davies ran the Little Girls' Club which included little boys for their shows. Here they are on the stage in the Parish Hall with Mrs Pennant (second from left, back row) who provided the music. Among the group are, back row: Jean Sutton, Susan Vile, Margaret Thompson. Middle row: Heather Griffiths, Camelia Griffiths, Elizabeth Jones, Jacqui John, Gillian Glover, Christine Wilson, Margaret Jones, Linda Wilson, Elizabeth Tope, Sally Roberts, Kathleen Spiller.

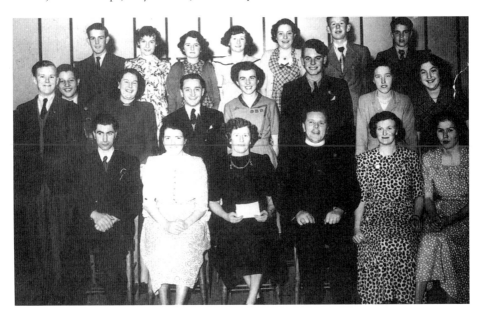

Church Youth Club, Easter 1950. Photographed in the Parish Hall at an end-of-session social are the committee and members of the Church Youth Guild, a branch of Cymry'r Groes, which flourished in the 1940s and 1950s. Back row: Bobby Griffiths, Norma King, Barbara Hardman, Pat Foy, Sonja Williams, Michael Gray, Keith Scott. Middle row: Bernard Sheppard, Alan Pound, Juliet Hilary Jones, Desmond Griffiths, Angela Everett, Clive Jones (Hockey Captain), Maureen Gadsby, Rosemery Pratt. Seated: Phillip Jones (Treasurer), Chrystal Tllney (Secretary), Mrs D.H. Davies, Revd D.H. Davies, Nancy Whiteside, Dorothy Hurlstone.

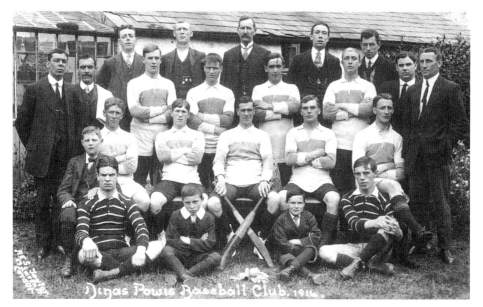

Dinas Powis Baseball Club, 1914, with Bill Barnett, coach, on the left. In Dinas Powys baseball was never as popular as tennis, cricket or football, but there was sufficient support in 1936 for a women's baseball team trained by Sid Bennett to be set up.

The One O'Clock Gate, the golf 'links', 1951. There are many theories as to why the gate bears this name. No-one at the golf club (founded in 1914) has yet come up with a really satisfactory explanation. The most popular theory is that the iron gate was given by Monty Williams and this was discussed at an impromptu meeting during a club dance at Bindles at one o'clock in the morning in 1951! Monty himself told his son that the night after announcing that he would finance the gate he woke in the early hours, looked at the clock, and decided on the name. The newspaper story that village elders used to meet here every Sunday at one o'clock (a.m. or p.m.?) is sheer bunkum!

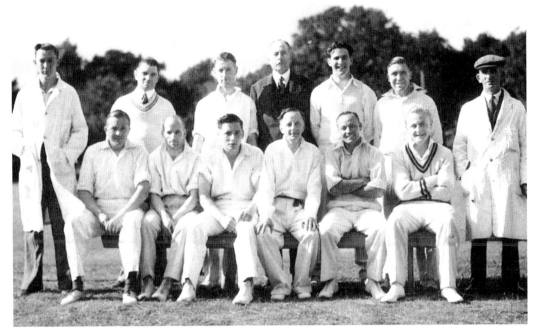

Dinas Powis Cricket Club. Formed in 1882, this cricket club has always played its home matches on the Common. Sir Ivor Thomas stands in the centre of the back row.

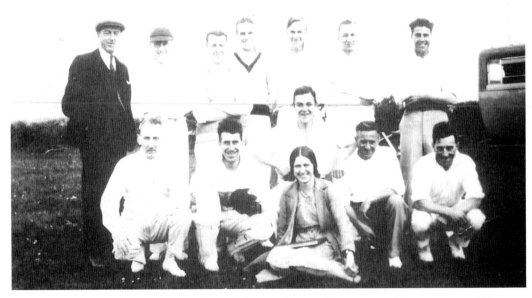

The Murch Cricket Club, c. 1930s. Residents of the Murch were able to muster their own team which played their home matches in the field behind Murch Road. From left to right, back row: Sid Bennett, Austin Davies, Bert Shepherd, -?-, -?-, A.F. Herbert. Front row: -?-, -?-, -?-, Bruce Davey, Will Hussey. Connie Minchinton (Mrs J. Phillips) was the scorer.

Opening of the Bowls Club. A meeting was held in The Cross Keys on 18 April 1902 to form the Dinas Powis Clubhouse Co., and the bowling green with its first small pavilion was laid out in 1907. Sergeant Peacock ('the old bird') presides over the first rubber. It was known as the Dinas Powis Lawn Tennis and Bowling Club, with the green and courts on the slope of the hill above the Common and next door to 'Merevale'. The land was bought from General Lee and there was a typical entry in his diary: 'The Bowling Club have a good bargain – I have kept my price low for the benefit of the Parish'.

Bowling group. George Ridout is on the extreme right of the front row. Fourth and sixth from the left in the second row are Alec Davis and Mr Burgess, respectively. Sir Ivor Thomas is sixth in the third row, and Mr Thompson, the cobbler, on the extreme right. In the fourth row is Bert Palmer, and on the extreme right Lot Thorne (headmaster of the Council School). In the back row are A.F. Herbert and Griffiths ('Meadow Way') and on the extreme right, Herbert Scourfield.

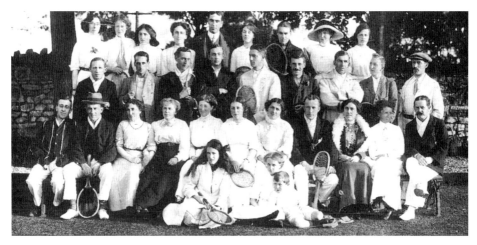

Dinas Powis Lawn Tennis Club, 1912. The tennis and bowls clubs divided in 1922. There is only one person instantly recognisable in this photograph taken ten years earlier, and that is Ralph Seel (on the right of the middle row). Readers may recognise their parents or grandparents among the gentlemen in cravats and blazers and the ladies who apparently found no difficulty in playing tennis in long skirts and high-necked blouses.

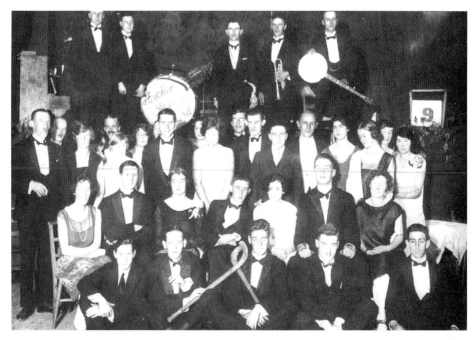

Tennis dance, c. 1933. This is definitely the tennis club! The hockey sticks were probably added just to confuse! Front row, second from left, is Alistair Seel and on the extreme right is Sidney Cravos. Second row, seated: Marge Beveridge, Dr Alex Beveridge, -?-, Bobby Graham, Billy Cravos, Victor Cravos, ? Lay. Standing: Ralph Seel, Carol Harper, Christine Seel, -?-, Carol (Roberts) Harper, -?-, Philip Harper, -?-, Winifred Graham, Geoffrey Isaac, Geoffrey Morgan, -?-, Phyllis Cravos, -?-, -?-, -?-. In the background is Archie Roberts' Band.

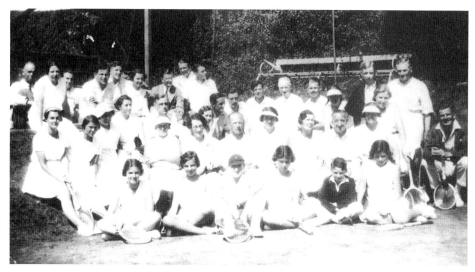

Dr Beveridge probably photographed this group on the courts for an 'American' knock-out tournament in 1937. Front row: R. Byrne, B. Bevan, C. Barnes, E. Edwards, L. Beveridge, J. Isaac. Second row (seated): W. Graham, M. Beveridge, W. Hoather, Q. Isaac, E.C. Jenkins and, on the extreme right, Roland Randell. Standing: M. Whiteside, H. Cochrane, P. Boyne, P. Kerr, F. Miles, S. Stoddart, P. Isaac, J. Randell, C.M. Morgan, B. Hoather, B. Perrins, L. Morgan, E. Barnes. G. Jenkins, S. Robertson. Back row: Professor Bevan, E. Laman, P. Ibbotson, B. Isaac, E. Morgan, J. Byrne, C. Laman.

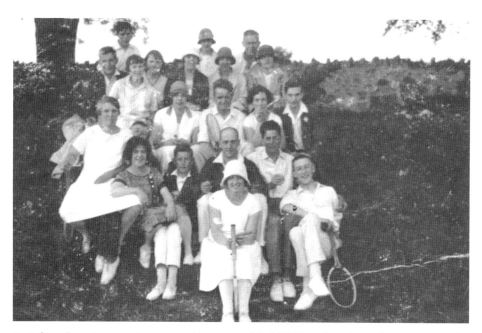

An informal tennis group, late 1920s. About 1924 Mr A.W. Pirie, then the gardener at 'Merevale', laid out three tennis courts behind the cricket pavilion in the field next to the Common. The founder members clubbed together to meet the expense. It was less formal than the lawn tennis club, but obviously enjoyed by this group which includes Harold Hardman, Nell Pirie and J.C.C. Rees.

Acknowledgments

One of the joys of compiling this book has been the sharing of reminiscences with those who remembered the old villages, notably Dick Williams and Jack Bevington. Like Percy Randell a generation ago, they were living links with our past. Many others have helped to identify people and occasions, but the author would be glad to hear from anyone who can fill the gaps and add to what has been written. Below are the names of those who have lent photographs and helped with specialist research. The author thanks them and apologises for any omissions or infringement of copyright. Note that the numbers below refer to page numbers with 'a' and 'b' used to signify whether the image appears 'above' or 'below' on a particular page and 'c' the right-hand image when two portraits are placed side by side.

Mrs E. Alexander (17b); author's private collection (70a, 105a, 109a, 110a, 117b, 118a, 118b, 119b, 120a, 112a and b); Jack Bevington (16c, 20b, 30a, 59a, 73b, 87b, 115a); John Byrne (114b); Barry Clemett (34b); Viv Corbin (70b, 88a, 88b, 90b); Miss Beryl Davies (16a, 27a, 53b, 81b, 97a, 97b, 123a, 124a); Dinas Powys Community Council (19, 29a, 29b). Dinas Powys History Society (6, 25a, 30b, 40a, 59b, 74b, 89a, 125a); John Dore-Dennis (39b); Mrs Peggy Durie (6, 17b, 48b, 51b, 61b, 71a, 80b, 83a, 91b, 94a, 96b, 99a, 100a, 101b 116b); Mr and Mrs Bruce Gardiner; Glamorgan-Gwent Archaeological Trust (19); Glamorgan Record Office (54a, 75a, 91a); Brian Granger-Bevan; Mrs Jan Gray (58a); Mrs Shelagh Gray (52b, 75b); R.W. Hall (10b, 27b, 28a, 34a, 35a and b, 36a and b, 37b, 38a, 39a, 54a and b, 56a, 58b, 60a, 63a, 71b, 72a and b, 77a and b, 78a, 90a, 103b, 123b); Miss E.S. Hardman (16b); Mrs Eleanor Hick (63b, 104a and b, 105b, 126b); Dr Peter Hilary Jones and Mrs Juliet Gorton (15a, 17a); Mrs Frances Hobbs (38b, 86, 114a); J.W. Hopkins (41a and b, 64a, 96a); William A. Horne, Lewiston, USA (113); Mrs Daphne Hurst (56b, 84b, 89b); Miss Margaret James; Dennis Hampton Jeffery (21a, b and c); Edward Jenkins (57); Miss Claire Jones (24b); Dr Haydn Jones (100b); Living Archive Centre for Barry and the Vale, Lowri Jones, Curator and Mr George Storey (12a, 13a, 18a); Hugh Matthew (81a, 107a and b); St Andrews Church-in-Wales Primary School (49, 50a and b, 51a, 52-53, 52b, 53b, 116a); Museum of Welsh Life and Arwyn Lloyd Hughes (18b); National Museum of Wales – Department of Archaeology and Miss E.A Walker (10a) – Library and Mr John Kenyon (11a, 28b, 40b); Mrs Eileen Orpin (55b, 83b); Miss Winifred (Ceri) Owen (2, 33a, 112b); Dennis Pope (25b); Mrs Angela Porter (115b, 119a); Roland Randell (69b) and for access to the P.G. Randell collection (8, 11b, 20a, 22a and b, 23a and b, 42a, 44b, 47a, 48a, 60b, 61a, 62a and b, 64b, 65, 66a and b, 67a and b, 68, 69a, 76b, 78-79, 82a and b, 84a, 85, 87a, 92a and b, 95, 101a, 102-103); David Rees; Revd Huw Rhydderch, Rector of St Andrews Major (for access to parish records and 13b, 15b, 31a and b, 32a and b, 33a, 73a, 76a, 76c, 78-79, 80a); Sid Rickard (93a, 93b, 94b); Mr and Mrs D.A Roberts; St Andrews Major Mothers' Union (Mrs B. Rhydderch) (14a and b); John Seel, for access to the records of Dinas Powys Lawn Tennis Club (126a, 127a); Mrs Valerie Shattock (124b, 125b); South Glamorgan County Libraries and Brynmor Jones of the Local Studies Department (9, 17b, 37a, 116b, 117a); South Wales Police Museum and Curator M.J. Glenn (106a and b); George Thomas (47b, 109b); Mrs Evelyn Tomlinson (121a and b); Walter Vile (99, 120b, 127b); E. Watkins; A. Welchman (108a and b); Mr and Mrs H.S. Welchman (24a, 26a, 33b, 55a, 112a, 123a); A.C. Williams (26a and b, 42a, 43a and b, 44b, 45a and b, 46a and b, 81c, 96a, 98a and b, 99b, 110b, 111b); Mr and Mrs Terry Williams (79b and the late Joe Foster; 70a and Mr Matthews); Stewart Williams for permission to extract from *Cardiff Yesterday* Vol. 2 and *Glamorgan Historian* Vol. 11.

For this edition – South Glamorgan County Libraries (4); Mrs Lettie Thomas (102b); Mike Goodfellow, present Clerk to Dinas Powys Community Council.

Lastly, my thanks to my long-suffering family and especially to my husband, Canon Mervyn Davies, without whose support and very practical help this book would not have been completed.